S. R. Badmin and the English Landscape

S. R. BADMIN and the English Landscape

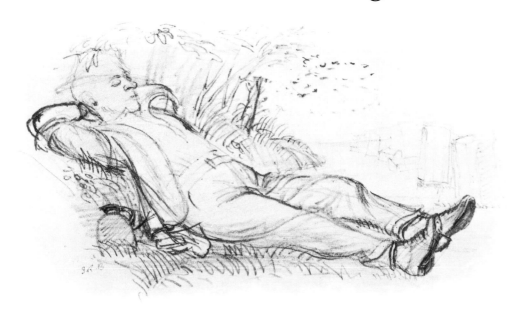

Chris Beetles

COLLINS

First published in the UK 1985
by William Collins Sons & Co Ltd
London · Glasgow · Sydney
Auckland · Johannesburg

An Albion Book

Conceived, designed and produced by
The Albion Press Ltd
9 Stewart Street, New Hinksey, Oxford OX1 4RH

Editor: Jane Havell
Designer: Emma Bradford

ISBN 0 00 412020 5

Typeset in Palatino by Katerprint Co Ltd
Colour reproduction by Dot Gradations Ltd and
Royle Publications Ltd
Printed and bound in Italy by Imago/Sagdos

*To my parents, Basil and Viola, who have always paid
the bus fare home*

Contents

Preface

June hedgerow,
Country Bouquet, *1947*

It is characteristic of Stanley Roy Badmin that he has responded with good nature and enthusiasm to yet another publisher's deadline. My thanks are due to him – and also for giving me the enjoyment of delving through his archives of sixty years of a busy working life. The role of his wife, Rosaline Badmin, has not been stressed in this book, but she has my sincere thanks for her support and generous hospitality (even her puddings come in threes, and all are delicious!). The close-knit privacy of their life is very important to the Badmins – I have respected this and eschewed the usual biographical convention of personality analysis and the interviewing of family, friends and contemporaries.

To Rosaline Badmin and Dora Flew go my thanks for information about the artist's early life and career. To those who have kindly lent their Badmin originals for reproduction in this book, I would like to express my gratitude. To Carol, who makes tolerable the pressures of an author's task, and to Frances, Tina and Renate, the team that enhances my working life, I also give my warmest thanks. Lastly, I would like to record my appreciation of Julian Royle of Royle Publications Ltd for his support of this biography – a support based on his wholehearted affection for the artist, and his belief that S.R. Badmin's name needs the recognition that the image of his work has already won in the minds of millions.

Introduction

The work of Stanley Roy Badmin has a unique place in the hearts and minds of the post-war generation. Nobody who has lived through this period of time will have failed to notice his bright and lucid illustrations for the Shell Guides, a 20th-century phenomenon of patronage whereby a multi-national oil company chose to sponsor art and artists through its advertising. Some of the best living British artists were chosen to illustrate these popular guides and Badmin's detailed and romantic pictures of the English countryside encapsulate the appeal of the whole series. Millions of Shell posters went into school classrooms and for many urban children this was their first contact with the beauty of the countryside. On hoardings, in magazines and at petrol stations all over the country, the Shell artists taught us to look again at our landscape and enjoy it.

Badmin's intense and meticulous watercolours have appeared on over a hundred greetings cards, Christmas cards and calendars produced by Royle's, the fine art publishers; they have illuminated book jackets and the covers of *Reader's Digest* volumes, and filled the colour plates of travel and topography books. When we see the British countryside, we often view it through his eyes. The *Shell Guide to Trees and Shrubs* on schoolroom posters and the didactic pleasure of Puffin Picture Books such as *Trees, Village and Town* and *Farm Crops* may have brought us into contact with him at an early age. Perhaps we took his illustrated travel books on holiday, or turned to read a nature book or a *Reader's Digest* because of the appeal of the cover. Often we might have looked at some advertising material because we admired its design, or browsed through *Radio Times* because of the lure of its cover in the days before colour photography took its garish hold.

The line of Badmin's drawings looks familiar to us, and the charm and colour of his landscapes are always enchanting. Everybody in Britain has probably at some time sent or received a Royle's Badmin – a green Cotswold valley, perhaps, or the Sussex Downs in snow. Badmin's image of the countryside remains in our mind, yet his name may be quite unfamiliar. The key to this is probably to be found in the neat, unobtrusive signature on the page. It is not just that these works of popular genius used by advertising agencies and mass communicators are done by a man who has natural reticence and seeks privacy. It is also that contemporary criticism has passed such work by, seeking to wrestle instead with something less representational and mistrusting the value of anything that is unashamedly enjoyed by millions.

S. R. Badmin is always keen for his work to speak for itself. It is a record of the unforced human response of the painter to nature – and his ability to evoke human moods and feelings in those who regard his work is the true measure of his success. This book describes sixty years of a working life that has been dedicated to hard work

September harvest festival
Country Bouquet, *1947*

eluded him for long. At the age of 26 he became one of the youngest ever members of the Royal Society of Painters in Watercolours and has remained committed to the society, England's leading forum for the best in watercolour art. His place in the development of the society in this century is looked at again, and the reasons for his present position as their most popular water-colourist are evaluated here.

Before the sudden slump in the British etching market in 1931, Badmin was a popular etcher of great distinction in the tradition of Samuel Palmer – a pastoral, idyllic tradition that he enlivened with contemporary subjects and the vitality of England between the wars. Though the years in which he produced etchings span less than a decade, it is interesting to consider how this aspect of his art developed and a *catalogue raisonné* lists his achieve-ments so far. The black-and-white illustrations for books on nature and the countryside, which followed from his etching skills and provided the basis for his later commercial appeal, anticipate the world of advertising and publishing that fully employed his singular vision of the world around us.

Since the day Badmin left the Royal College of Art in 1928, his craft has been based on hard work and experience, and his talent on a love for and deep knowledge of the British countryside – parti-cularly Sussex where he has lived in happy seclu-sion for the last 25 years. Alongside the colour plates of his work reproduced in this book are associated memories and technical insights from the artist himself, which enable us once more to share his pleasure, as we learn to look again at the countryside around us.

S.R. Badmin drawn by P.F. Millard, 1932

P.F. Millard drawn by S.R. Badmin

and craftsmanship, which reveals a man without self-consciousness who is prepared to work hard at a job that he loves.

S. R. Badmin is a happy family man who regards success as the state of being constantly in work – a state that, throughout his long career, has never

Apprenticeship and early success

'I have always loved the country, nature.' This simple affirmation by Stanley Roy Badmin was prompted by memories of his early childhood. Some of the earliest positive recollections of this son of a Sydenham schoolmaster – the second of three children – are the family's visits to Somerset. Badmin's mother (also trained as a teacher) was, like his father, from Somerset and they often went on family trips to the village of Holcombe in the Mendips to visit the children's grandfather. 'The whole family would go to Somerset. We continued to go even after grandfather died, and after my marriage.'

Badmin's grandfather was the village carpenter and a skilled cabinetmaker, whose craftsmanship made a great impression on the young boy. These family holidays were his first introduction to country life and manners – an education that was confirmed by regular day-trips out from the London suburbs made with his parents throughout his schooldays. 'Mother and father had lived in the country, and always had this keenness to be in the country.'

Years later, in his twenties, Badmin's talent matured and caught up with fond memory. He then lovingly recalled and recorded family days in the Mendips with a faithful etching inspired by Holcombe called 'Field Corner'. His predilictions for art – and for sport – were noticed young. His schoolmaster father, a very keen sportsman himself, would have encouraged the latter, but Bad-

min's emergent ambition to be an artist at first got a cool reception. 'Parents, after efforts to get me into a "safe career", were very supportive. I think they thought banking would suit me!'

In 1922 Badmin won a scholarship to Camberwell Art School, where he remembers Cosmo Clarke RA and Thomas Derrick. Cosmo Clarke was the visiting teacher of life painting at Camberwell from 1921 to 1938 and Badmin considers him to have been quite an influence on his early disciplines of painting and drawing. Thomas Derrick did much to direct him to compatible subjects: 'He gave me a good talking to about painting things around me and not ladies in crinolines.' Badmin learnt the lesson well from the beginning, as may be seen from his 1926 sketch of Dartmouth Road, Forest Hill, SE23 (page 14), later reproduced in the 1931 Christmas edition of *The Sphere*.

Professional prudence on the part of his parents continued for, after a year, they arranged some private education in general studies for him. Badmin certainly did not regret this, but it had to take second place a year later when he won a studentship to the Royal College of Art. His first year from 1924 to 1925 was spent at the painting school. The Royal College had at that time been revitalised by Professor William Rothenstein and the list of Badmin's teachers is impressive. Professor Tristram, the head of the design school, is remembered by Badmin as being generally very encouraging during his weekly session in the

second year, when he had switched from painting to design. The transfer came with the blessing of Professor Rothenstein, whom Badmin recalls as a tyrant, though he saw little of him since, at this time, Rothenstein was involved in a major commission, doing the 'history of Britain' murals in the Houses of Parliament.

Randolph Schwabe taught drawing: 'fantastic draughtsman and a wonderful illustrator, especially in the figure drawing'. He became the Slade Professor in succession to Henry Tonks in 1930. Ernest Michael Dinkel was the teacher in charge of the mural and decoration department in the design school. He and Badmin were to become fellow-members of the Royal Watercolour Society, and

Dartmouth Road, Forest Hill, 1926

were 'always very good friends'. Meredith Hawes has 'remained friends, a very outward-going person, and a lot of fun. He just cannot stop teaching.' Though they never became close friends, Edward Bawden is distinct in Badmin's memory: 'I admired Bawden, top of the school at the time, a very nice man. We used to admire his work very much.' Ceri Richards, who was in the same class for design, also made an impression: 'Admired by all, I suppose. Very naturalistic then, later admired for the modern movement.'

Badmin was working very intensely at this time, especially after his switch to the design school, but found it all very enjoyable. He continued to live with his parents in Sydenham and commuted daily into town on the tram. In his third year he followed illustration, architecture and interior decor, spending several evenings a week on book illustrations. A precocious and conscientious student, he was awarded the Diploma of the Royal College of Art in 1927. A year of teacher training followed, with evenings at Camberwell Art School studying metalwork and jewellery, and at the Royal College doing pottery, bookbinding, engraving, wood engraving and etching. In the etching department, he made two very important contacts: Professor Malcolm Osborne and his assistant Robert Sargent Austin, appointed by Professor Rothenstein in 1926.

Formal teaching for Badmin ended in 1928 when he received his art teacher's diploma. The standard response of artists at this stage is to try to find a teaching post, and this Badmin did. 'I turned down one or two full-time jobs which I applied for – one was in Newport.' By now, money was trickling in. His etching tutor Robert Austin was

always encouraging and, through him, Badmin got an introduction to the Twenty One Gallery which was an excellent start. The aptitude he had found for etching in his last year at the Royal College was diligently pursued, and the public took up his work readily in what was still a boom period in the etching market.

Other work and sales had also begun to come his way. On 21 May 1927 he had his first colour reproductions published in *The Graphic*. These were two watercolours: 'A Scar on the Kentish Countryside: the new Maidstone Road above Wrotham' and 'Spring Cleaning, London: A Seasonal Scene in South Kensington'. The censorious title of the first rather belies the jolly scene of travellers and denizens of London and, if the new Maidstone Road was a scar, it was a neat one and already healing well.

By 24 August 1928 *Tatler* had discovered Badmin's talent for eye-catching, detailed panorama, and printed his picture of Dover on a double-page spread. In the same year his versatility and feeling for contemporary design were given full scope in his art-deco rendering of the programme cover for the Pavilion Hotel, Scarborough – a job he got through the recommendation of the Curwen Press.

Sales at the Twenty One Gallery continued and the overall feeling of the young artist at this time was hopeful. Encouraged by his first one-man show at the gallery in January 1930, and by a firm promise of £100 per quarter from them, he decided to get married. He was introduced to his wife Peggy by a fellow-footballer: 'I used to live for my Saturday afternoon football.' Apparently a very good and nippy right-winger, Badmin had his

hour of glory when 'I played for the Metropolitan Water Board on the strength of my watercolours . . . ending up scoring a goal against Ipswich Town in 1934 when they were amateurs, so that's going back a bit!' One resource that an artist keeps with him over the years is his vividly-held memory of personal experience. The excitement for Badmin of footballing days is recalled in 'Here they come! the Valley', a watercolour done in about 1950 for a competition sponsored by the Football Association. The resulting exhibition was rather grandly titled 'Football in the Fine Arts' and attracted entries from many well-known names, such as L.S. Lowry and Claude Rogers. S.R. Badmin's entry is full of the roar of the crowd in its pre-match excitement; his pencilled annotation in the catalogue reads, 'Won a small prize with this.'

The economic depression following the crash of the U.S. stock market in 1930 caught up with the art market in Britain. The etching market, founded on a speculative boom, collapsed and in 1931 sales of Badmin's etchings, hitherto very good, dwindled to nothing. He bought his own printing press and, the following year, transferred himself from the Twenty One Gallery to the Fine Art Society.

Reviews of Badmin's work had been consistently enthusiastic since he had left the Royal College of Art and in 1932, at the early age of 26, he was made an Associate of the Royal Watercolour Society. *The Times* critic immediately picked him out at the April exhibition of that year as one of the main attractions: 'If Mr Badmin is put first it is because he accepts more completely than the others the convention of line and wash. . . . Mr Badmin makes no bones about his tone and the result is that drawings like "Mill Street, W." and

Programme cover, 1926

"The Season Commences – Richmond" give complete satisfaction.' The *Morning Post* was equally impressed: 'The most interesting contributions this year are in scale the most modest of all. They are extremely delicate little drawings, packed with facts, by the young etcher, S.R. Badmin. Nothing in them is shirked and nothing merely suggested. With a penline of remarkable finesse, Badmin works out all his contours, and then floats over all quiet and binding washes of colour. Of his five contributions, no. 90, "Cornish Mill Farm", is one of the most desirable watercolours I have seen for many a day.' *The Scotsman* found similar pleasures: 'The most interesting drawings in this show are provided by S.R. Badmin, a young etcher who uses line with almost an etcher's delicacy and precision. Badmin is almost miniaturist in the fineness of his work he packs into a small picture area, but in spite of all this wealth of beautifully designed detail, he contrives, with the aid of washes of tender colour, to preserve a seemly order in all his drawings.'

By the time the Winter Exhibition of 1932 had come round, the column inches on Badmin were growing. From some established members of the R.W.S., so too was disgruntlement at the disproportionate amount of attention the young artist was getting – a surprising response even in a profession not noted for its magnanimity. Though *The Times* critic turned 'for relief to technical intensity' and remarked that 'for this reason the landscapes of Mr Badmin are particularly welcome,' full membership for him as a Fellow of the Royal Watercolour Society was delayed until 1939.

Good reviews in the press, however, do not pay the bills and by now Badmin had a family to feed, with his son Patrick already one and his daughter Joanna on the way. He switched to teaching, and Richmond Art School employed his talents on two mornings a week. There was a pleasant 'studio atmosphere' about the Richmond school, and Badmin's previous unhappiness about teaching was soon forgotten (his first job had been a month of supply teaching – 'Horrible, as a secondary school art master I had a class of 30 or more . . . as a first teaching job it was pretty dismal and didn't last very long'). And down by the Thames at Richmond there was a new area to explore. The stimulating proximity of the river enchanted Badmin and he produced some of his best work at this time, such as 'Isleworth Reach' (page 67) and 'Eel Pie Island', both illustrated in *The Studio* of February 1933. Richmond Art School has further importance for Badmin as the place where he met P.F. Millard, who had taken over from Raymond Coxon as the main teacher of life drawing and painting.

The first of Badmin's Fine Art Society exhibitions took place early in 1933 and was, happily, successful – over a third of the exhibits were sold. As always in harder economic times, the best watercolours sold easily. 'Woodchester, Gloucestershire', sold at 38 guineas, was reproduced in the March 1933 issue of *The Sphere*. A remarkable, panoramic view down into a tightly-ordered Cotswold valley, it was an indication of what was to come regularly from Badmin whenever he came into contact with this stimulating and picturesque part of the country (see pages 69 and 71). 'Blackheath Village', sold at 34 guineas, was a view from the heath which showed S.R. Badmin at his best. It became a full-page colour reproduction in a five-

page article in the February 1933 issue of *The Studio* which was entitled 'S.R. Badmin: a modern British watercolourist'.

Once more the press rallied round their new find. The *Sunday Times*, after heading with 'A new aquarellist: the art of S.R. Badmin', summed up the story so far in sensible and careful rapture:

> Mr S.R. Badmin ARWS, ARE, is a young artist with very remarkable gifts. At the early age of 26 he has won his way, by sheer merit, into the ranks of two important royal societies, the Painter-Etchers and the Old Watercolour Society. But while he is a valuable new recruit to their ranks, the peculiar virtues of his art can be seen to much better advantage in his first one-man show at the Fine Art Society. His watercolours and etchings are distinguished by a thoroughness which is as refreshing as it is rare he has a passion for enriching the content of his compositions by a multitude of detail; but the most wonderful thing about his work is that, while he is scrupulous – but not over-scrupulous – in his precise drawing of minute detail, he contrives to combine this quality with breadth and simplicity of effect.

The critic's pleasure is final: '. . . to be satisfying both at close range and at a distance, is exceedingly rare in pictorial art, and speaks volumes for the skill and good judgement of so young an artist.' But still he has time to notice a growing feature of Badmin's art at this time – he was beginning to use the etching needle less, and to set out to please his new watercolour-buying public much more: 'While the precision and sensitiveness of Mr Badmin's line are features both of his etchings and of his watercolours, he has the tact to know when it is advisable to sacrifice his linear principles. Striking evidence of this is afforded by his watercolour of Wareham Pool entitled "The Evening Water-Polo Match" (56), in which the telegraph wires, instead of being rendered by lines, are most happily suggested by an almost magical wash of tone. His colour is quiet rather than brilliant, but it is clean and harmonious.'

This critic, too, was the first to notice and describe Badmin's working method: 'Drawings of this integrity are obviously not to be achieved by the artist's "first fine careless rapture", and some light on Mr Badmin's infinite capacity for taking pains is thrown by the presence at the Fine Art Society of some of his studies. We have only to look at the notes made out of doors (nos. 18 and 19) for "Blackheath Village" and "Ludlow" to perceive their informativeness, and when we turn to the resulting watercolours we see what good use the artist has made of the material collected by his thoroughgoing industry.'

In this exhibition, there were no takers at all for the etchings, confirming the end of that particular source of income for Badmin. His total sales came to £323 18s 6d and this, together with R.W.S. sales and intermittent requests from magazines such as *Tatler* and *The Graphic*, kept the Badmins through these struggling years.

Another successful showing, this time at the 1935 Winter Exhibition at the R.W.S., brought an important fillip. *Fortune* offered Badmin his first major commission. This U.S. publication was then, as now, a prestigious mass-market magazine. It had been founded in 1930 by Henry R. Luce as part of the growing Time Inc. publishing empire. Every other year, *Fortune* invited an

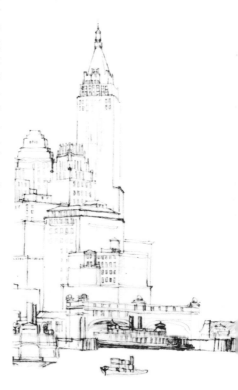

The New York skyline, 1935

important foreign artist to do a series of illustrations for them. That it was a 'terrific honour' Badmin was well aware, but the innate paranoia felt by all British artists about publishers at that time made him suspicious of them, and he made absolutely sure that everything about the contract was signed and sealed.

But once he got to America, however, it was immediately clear that artists were important there and they were treated well. *Fortune* gave him first-class travel everywhere, and paid for board and lodging 'in a big way'. Badmin, however, did not realise this and, when he was 'sent to a typical farm in Illinois' for six weeks, 'bought marvellous presents for the family including a baseball bat for the boy and something for the girl.'

The American tour started after his ship from England docked at New York. Drawings there were not part of the commission, but he did find time for some sketching. 'Patchin Place, Greenwich Village' (page 19) was given the Badmin touch that lightens an urban scene, and almost

Market Square, Williamsburg, 1935

makes us feel as if we were looking down a turning off Cheyne Row in Chelsea.

Williamsburg was the first sojourn with the sketch pad. This Badmin enjoyed – 'home from home', he described it, 'with beautiful Georgian architecture.' The *Fortune* editors could not have made a better choice of artist for this task, and Badmin's six pictures of Williamsburg are very fine indeed. His arrival had been timed perfectly, since Williamsburg had just been made ready for a connoisseur's inspection. Ten years of work on the town with no expense spared had just been tastefully completed. *Fortune's* heading for the article that accompanied Badmin's pictures read: 'Mr Rockefeller's $14,000,000 idyll . . . which is the Colonial City of Williamsburg, Second Capital of Virginia, now restored to history.' The clean lines of the 'Georgian tradition' are peacefully captured by Badmin in his wide view of 'The Market Square Tavern, Old Courthouse and Powder Magazine', and his elegant 'Palace of the Governors of the Virginia Colony', surrounded by tall trees.

Philadelphia was next on the whistle-stop tour and there Badmin responded to the bustling charms of the 'Chinese Wall' and 'Broad Street Station' and the jostling Model-T Fords on their way down 'The Parkway', the wide vista that heads from the museum direct into the heart of town.

An exhibition of all the work done on the trip was arranged in New York. 'Patchin Place' and 21 others from the Williamsburg, Illinois and Philadelphia sets, together with English work and fifteen etchings were exhibited at McDonald's Gallery, Fifth Avenue, in March 1936.

Badmin took advantage of his situation to ask

Fortune if his return ticket could be altered for him to travel back by way of Canada. They readily agreed and, as a result of this, 'Quebec from the Ramparts' and 'Buoys in the Marine Yard, Quebec' were exhibited in the Spring Exhibition at the R.W.S. the following year. They had great power in terms of design, but Canada was obviously not in fashion that year and they did not sell until 1944 and 1970 respectively. But 'Buoys in the Marine Yard, Quebec' was given a full page in colour in the June 1936 issue of *The Studio*, where a second Badmin from the same exhibition was also selected for a full page reproduction in black-and-white. In this remarkable watercolour, 'Yorkshire Wood', Badmin's work comes close to abstraction, as the forest sways rhythmically in a whirling skein of trees above the geometrical shapes of rocky outcrops (page 40).

Back in England he took on an additional teaching job to help out his finances: one afternoon a week teaching an etching class at St John's Wood Art School. The new co-principal was P.F. Millard RBA, a colleague from his first days at Richmond Art School, who seems to have been an artist and teacher of great charisma. Badmin's warm admiration for him as a man and a teacher are always expressed without his usual reserve and restraint. 'He began to make me realise about design more deeply. He was a born teacher – every moment learning something from him.' Their sketches of each other, shown on page 12, reveal seriousness and sensitivity in both men. Millard went on to become Principal of the Regent Polytechnic and then of Goldsmith's Art School, and Badmin joined him in several sketching classes: 'I felt I was learning more than teaching.'

Patchin Place,
Greenwich Village, 1935

Meanwhile, days of hard work continued at his studio in Clapham Common. Throughout his life Badmin has tried to keep what he calls regular 'Art School times', starting at 10am usually every day except Sunday. His work continued to attract good notices both at the Royal Academy, where his 'sensitive use of line' was noted and at the R.W.S. His sales ledger records these successes; 'Whitestone Pond, Hampstead' was also published in the October 1936 *Tatler*.

Football remained important in the Badmin

scheme of things: amongst his studio ephemera is a directive from the Casuals Football Club, dated 2 March 1936, informing him that he had been selected to play against London Hospital away, and that he was to be at Liverpool Street Station by 1.30pm to reach the ground for a 2.45pm kick-off. A white shirt was required rather than the usual 'Casuals' clobber' – and they won.

Badmin remembers 1936 vividly, as the time when his political awareness began; his beliefs have never left him since. This was the time of the Spanish Civil War, and only a little influence was needed from James Holland, a colleague from art school days, to persuade him to join the Artists' International Association – a group of concerned artists from the liberal left who had joined together with the aim of increasing public awareness of the rise of fascism in Europe. The meetings of the Left Book Club, an initiative of the publisher Gollancz, were held at his studio in Clapham. 'We were working in those days for friendship and peace with Russia – Stafford Cripps' ideas There were many potential Quislings in that pre-war government; Hitler was going to bash Russia, so to them that was all right. . . . Many of the artists sold work in aid of A.I.A.: Tunnicliffe, Pitchforth and, of course, the three "Jimmies" – James Holland, James Fitton and James Boswell. . . . We got the money together for a magnificent yellow ambulance. . . . It was captured in one week by Franco's forces.' The only individually-published lithoplates Badmin ever did were for the A.I.A.: 'Skating on Dulwich Park pond' and 'Barrage balloons on Clapham Common' (left). This was an 'art for the people' idea, printed by Everyman Prints, and the two prints sold for only one shilling each.

Badmin's political concerns did not end with the defeat of fascism after the second world war; back in civilian life, he continued to involve himself in the Sydenham and Forest Hill Peace Group. His papers contain many letters from national and local government departments, including one typical example – a bland reply of three lines from a civil servant acknowledging the resolution sent to the Foreign Secretary by the Peace Group, concluding: 'the contents of which have been noticed'!

At a period of no great activity in commercial art S.R. Badmin found himself increasingly in work. An exhibition at the Fine Art Society in June 1937 was moderately successful; one watercolour, of Stowe House, sold at £35. Only four etchings were

'Barrage Balloons on Clapham Common', 1939

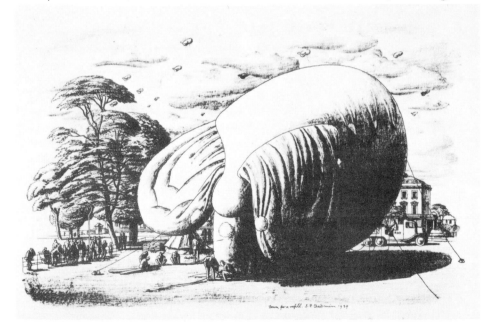

exhibited, a mark of reduced confidence in their earning ability. They were still priced between two and a half and four guineas, and none of them sold. It was also in these years before the war that Badmin, with regret, resigned from the Royal Society of Painter-Etchers. He could no longer afford to do many new etchings, especially when sales were so poor. The three and a half guinea subscription to the R.E., though it seems a paltry sum now, was then an important part of his yearly family budget. Furthermore, the number of fellows admitted to the R.E. was limited and Badmin felt that his inactivity as an etcher was keeping out a suitably practising replacement.

In 1937 Badmin received his fee from Macmillan for his illustrations for *Highways and Byways in Essex*. The importance of this book in the development of his art is touched on later (pages 45 to 63). The commission was a welcome one and the task enjoyable: Badmin had just paid £9 to buy his father's car – the Morris 10 that appears in his etching 'Mill Street, W.' (page 59) – and in this he travelled about Essex doing his sketching.

He already knew some parts of Essex from the previous year when he had occasionally gone to stay in the Assington area, north-west of Colchester, with fellow-artist Percy Horton at his country cottage (the etching, 'Derby and Joan Cottage', was based on a pretty rustic home near Bures in the same area). The two men had become friends through the A.I.A., when Horton had lived in Dulwich, near Badmin at Sydenham Hill. In 1916, at the age of 29, he had been imprisoned as a conscientious objector and his political beliefs remained firmly with him throughout his long life. He was a student at the Royal College of Art between 1922 and 1924, returning to teach there from 1930 until 1949. From 1949 to 1964 he was, suitably, Professor of Drawing at the Ruskin School in Oxford. Later he lived for a while in the Keeper's Tower at Firle Park, East Sussex, where Badmin produced a good watercolour while staying one weekend.

In 1938 a trail of events began that was to take Badmin into the important area of educational illustration. He did some originals on farmwork for the magazine *Pictorial Education* and was then asked for four 'typical villages'. Shortly after this he made his first lithoplate for the A.I.A., 'Barrage Balloons' and 'Digging a gunsite on Clapham Common'. James Holland, another member of the A.I.A., had already done *A Book of Insects* for the

'Digging a Gunsite on Clapham Common', 1939

prestigious series of Puffin Picture Books and, on the strength of Badmin's recent work, recommended to the editor, Noel Carrington, that he be employed to illustrate the proposed *Village and Town*. Noel Carrington turned out to be an important man in Badmin's life, and their professional relationship was inspirational and productive. While art editor of *Country Life* in the early 1930s, Carrington had had the idea of using auto-lithography to produce well-illustrated, attractive and colourful children's books. It was a method of illustration already successful in France and Russia, and Carrington was able to persuade Allen Lane, founder of Penguin Books, to embark on this important and pioneering series.

For the process of auto-lithography, the artist works directly onto the plates. *Village and Town* was published in 1939 with sixteen colour pages, done on four plates. It is pleasant to note that, on a book that was to become so popular, payment to the artist was made by royalties on sales.

After *Village and Town* Badmin did two more in this enduring series. *Trees in Britain*, published in 1942, was written as well as illustrated by Badmin and it is, from end-paper to end-paper, a masterpiece of design and clarity. Carrington helped with suggestions – such as including pictures of the uses made of timber. These little 'still-lives' in wood add great pictorial and educational impact to the book: cricket bats and toys from willow, margarine crates from poplars, butter pats from sycamore, piano parts from beech, mill-wheel cogs from hornbeam, mallet heads from crab-apple and ships from common oak.

By this time Puffin Picture Books had a stable of famous artists – Frank Mason for *Famous Ships*,

R.B. Talbot Kelly for *Birds*, Edward Bawden for *The Arabs* and Lionel Edwards for *Horses*. It was not until 1955 that the last book of the series, *Farm Crops*, was produced by the irresistible Badmin and Carrington team, with a text written by Sir George Stapledon, a renowned expert on grasses.

The world has changed sufficiently fast to make the book look outdated now. While it was in preparation in 1954, mechanisation was already making some of the pictures, showing horse-drawn carts and laborious methods of harvesting by hand, look increasingly obsolete, while machines such as combine harvesters were still a new and curious image to many.

The importance of all these books to millions of students is not just that they may have been their first enticing contacts with cathedral architecture, unusual trees or farmyard machinery, but that the information endured through clear and strong images, simple and readable text and, above all, well-researched accuracy. The books in this series are now all collectors' items – not only on account of their didactic force, but due to the recognition of art and design of the highest quality.

Planting out in June,
Russell Square

A working artist

The outbreak of war in 1939 did not diminish the 'immediate success' for Badmin of the Puffin Picture Book *Village and Town*. The royalties brought him welcome fees in those days of stringency, but the greatest satisfaction he remembers from this and the whole series of books is their sheer usefulness. 'They were invaluable in the days of evacuation during the war, when children were coming from the cities into the country and were asking questions about trees and other things. They were useful to adults because they were carefully researched and edited. Nobody faulted the trees, but when I did a similar book on architecture I got a little criticism from one or two architects.' The importance of Badmin's work on *Trees in Britain* was widely recognised – in view of its educational value, the artist's call-up into the R.A.F was delayed to allow him to finish it.

Before starting work on *Trees* in 1941, Badmin's employment came mainly from two sources – The Pilgrim Trust and the Ministry of Information. The Pilgrim Trust entirely financed an enterprise called the 'Recording Britain Scheme'. A small committee was set up in 1940 to administer the project and to select the drawings. Two of its members were Sir William Russell Flint and Percy Jowett RWS. It was hoped that the scheme would record views and buildings in England that were at risk – from building development, vandalism, the neglect of time and now, more urgently, imminent demolition by enemy bombs. Badmin remembers also its

other aim – to give work to 'starving artists'. He recalls that he was paid about £8 or £9 a drawing, but this may be the gratitude of memory since official records declare that the contract with each artist was for a payment of £24 for four weeks' work, during which eight drawings were to be produced; any additional drawings could be sold to the Trust separately.

Artists were allocated different areas of the country. Charles Knight (dubbed the star of the series by Russell Flint) did his forty drawings in Sussex, sharing the area with Rowland Hilder, Alfred Hayward and Adrian Hill. S.R. Badmin supplied and had accepted some drawings already made, such as 'Holy Trinity, Clapham Common', but his main task was to record certain sights in Bedfordshire, Buckinghamshire and, in particular, Northamptonshire. Most of his travelling was done by bicycle and, most usefully, he found a bungalow in Ashton, near Roade, not far from where he did a picture of Stoke Bruerne, to which he was able to transfer his parents during the evacuation from London in the Blitz. *Recording Britain* was brought out by Oxford University Press in three volumes – the first printed in 1946 and the second in 1947. Badmin's contribution to Volume One is seven drawings: 'Holy Trinity, Clapham Common', 'Bow Brick Hill, Bletchley', 'Leckhampstead', 'Near Lidlington', 'Felmersham', 'The Round House, Harrold' and 'The Ouse in Flood, near Harrold.' To Volume Two he contributed

eight drawings: 'Melford Hall, Long Melford', 'Cosgrove', 'Stoke Bruerne', 'Boughton from the Park', 'Grafton Underwood', 'Bulwick', 'The Mill, Duddington' and 'Colly Weston'.

His work for the Ministry of Information came through the good offices of Misha Black who had been Chairman of the A.I.A. and was now, in the first few years of the war, 'something high up in the Min. of In.' Badmin was given the job of getting up the architectural plans and drawings for the travelling exhibitions that Misha Black was organising to take information from the ministry around the country. One travelling exhibition was done inside a van which went to village greens. The theme was the A.T.S. and the exhibition was to encourage enlisting – it was hoped that the persuasive pen of S.R. Badmin would achieve this with his attractive sketches of A.T.S. life. Another exhibition, a travelling display to explain the war effort, was sent to Chicago.

Later in the war the Min. of In. commissioned him to decorate the end-papers for a booklet about the Home Guard. Though it did not set out to have the disturbing force of a 'Kitchener Needs You!' poster, there is obvious appeal in its chunky, dependable figures of soldiers guarding their island heritage, with just a hint of domestic derring-do. This particular job was given to Badmin by E.J. Embleton of the Min. of In., who was later to become an important employer of his talent as art editor of Odhams Press.

Badmin's call-up to the R.A.F. came in 1942. After the initial induction at a camp in Skegness, he was set to work on operational model-making near Henley. Initially, at the outbreak of war, he had put in for Camouflage but had been turned down. This was both a puzzle and a disappointment to the keen young artist: 'I wondered whether it was because I recognised fascism too early, or perhaps they wanted public school lads, sort of officer types.'

The types he met in the model-making project, however, could not have been more congenial. 'It was an absolutely marvellous job, working with so many well-known artists, architects and commercial artists. They were a nice lot to work and live with.'

Badmin's particular section, headed by the famous sculptor, Deeley, was based in Medmenham R.A.F. camp. The section was housed in two big huts in the typical Nissen hut camp, beautifully situated a few miles down the river from Henley-on-Thames.

The artists worked closely from aerial photographs, from which comprehensive models were made of proposed landing beaches. Regular new photographs kept them up to date with any changes of haystack or barbed wire. 'We ended up doing the whole of the northern French coast and large models of planned landings. We did the Dieppe raid and models of the cliff and where the houses were. They could see where their cover could be – a ditch or haystack or potato clamp. The terrain was always changing. It might be different the next month. For the whole of the Normandy landing the model was huge. I hadn't done any modelling until then – not many people had. The key figure was an old boy who could cast the models, because copies were needed. We eventually got on to casting them in PVC and that helped that particular commodity to develop. The models, I believe, are now in the Imperial War

Museum.'

It was at Medmenham that the department interpreting aerial photography discovered the German rocket bunkers. Badmin remembers that Churchill's daughter, Sarah, was there on the photographic side. And later in the war the group was joined by Americans. During this time Private Badmin 'eventually rose to Corporal, on my way to becoming a Field Marshall!' Wilfred Fairclough RWS was a Sergeant there at the time and the talented silversmith L.G. Durbin a Corporal. The R.A.F. allowed Durbin out on loan for a while to work on the famous Stalingrad sword, described in a 1944 edition of *The Studio* as 'perhaps the most important work of art of our generation owing to its intrinsic beauty, fine craftsmanship, and to the circumstances in which it was produced. Presented by His Majesty King George VI to our Russian Allies to commemorate a great feat of Arms, the sword was designed by R.M.Y. Gleadowe and produced by a team of British craftsmen.' Durbin did the gold and silverwork, the quillon and the fittings of the scabbard.

Arthur Henderson Hall, later to become a member of the R.W.S., transferred to the Medmenham section from the Kent regiment, and he and Badmin immediately struck up a life-long friendship. A Corporal's pay, it was thought, was not enough on which to keep a family, so this enterprising duo set up and shared a studio in Henley-on-Thames. Both of them found enough work to keep busy sketching and painting in their ample free time. The odd task kept coming to Badmin from the Min. of In. – in particular he was asked to design a poster for the Arabs, 'to show them the delights of English country life', the request accompanied by an emphatic instruction that the poster was to be without any sign of pigs.

Time off to see his family and to continue his sketching was for Badmin the most important part of camp life. He achieved a splendid and joyous celebration of that notion with a large oil on canvas called 'The Weekend Pass', done for the mess in 1944 (page 25). On looking at this enormous canvas (67 × 45in/170 × 114cm) it is easy to share the liberated feeligs of the R.A.F. and W.R.A.F. types who almost flow out of the gates of the camp. Kit bags packed, they hurry out on foot and on bicycle, packing into buses and thumbing lifts, all on their way to a weekend of freedom from service routine.

During the last days of the war, Badmin spent some of his leave time at the Royal Botanical

'The Weekend Pass', 1944

Gardens at Kew. These were pleasant visits for him, and he has ever since maintained an interest in winter-flowering shrubs, as his mature and lovingly-tended garden in Bignor now shows. Throughout the winter season there are successive patches of colour to brighten the drab winter covering, from the November profusion of bright purple berries on the *Callicarpa rubella* to the yellow and fragrant spikes of December's Mahonia.

Pleasant though his visits to the Botanical Gardens were, much of this herbaceous swotting was in preparation for a remarkable and important book published immediately after the war in 1947. It had been in preparation during the war years by the Association for Planning and Regional Reconstruction and, as it says idealistically on the dust wrapper, 'it looked forward to a renaissance of tree-planting which could make as bold and beautiful an impress upon the English landscape as the stately avenues of large trees in the spacious grounds of country houses, the dense islands of woodland planted as game preserves, and the network of tree-studded hedgerows of our 18th century ancestors.'

Some of the aims of *Trees for Town and Country* were successful, for it was from the beginning a very cleverly conceived book. It gave a selection of sixty trees suitable for general cultivation in England, and described the time of planting, the soil, the climate and habitats most suitable for them. The leading landscape architect Brenda Colvin wrote the text, but much of the success of the book lay in the method of presenting S.R. Badmin's exquisite line drawings. By the side of a scale of about 100 feet (30.5 metres) stood the figure of a six-foot (1.8-metre) man and by this were several scale drawings of the tree as it would look over the years. With three drawings, for instance, we were told that the Lombardy Poplar would be 18 feet (5.5 metres) in six years, 35 feet (10.5 metres) in fifteen years and 90 feet (27.5 metres) in seventy years, and that it was 'especially suitable for Roadside, Town, Street, Windscreen.'

The sixty trees in the book were selected by the Royal Botanical Gardens at Kew, the Institute of Landscape Architects, and the Roads Beautifying Association. Much of the newly-planted look of post-war Britain comes from the direction of this book which became, in effect, the tree-planters' reference book. It was taken up with enthusiasm by members of local authorities, landscape artists, town planners, architects, preservation societies and, of course, the general public who were

'Quebec from the Ramparts',
1935

increasingly conscious of their environment. By 1949 it had already gone to a third edition. Badmin is generous about the contribution from Brenda Colvin to the success of his drawings. 'I learnt a lot from Brenda Colvin. She taught me what to look for in trees – the angle of branches, for instance. Every specimen has its angle of growth. It is quite incredible. I did the trees in winter and also in three stages of growth, at planting and after about 25 or thirty years. An architect could see how a tree would develop and end up.'

Although war work came first, Badmin and Henderson Hall directed some of their energy to commercial work in their studio at Henley. Work came in fast enough to keep their spare moments occupied, and Badmin kept in touch with the wartime R.W.S. exhibitions. Though there were no Badmin contributions to the 1942 autumn and 1943 spring exhibitions, he was back on form with three works in the 1943 autumn exhibition – one was a local view with the enticing and enigmatic title, 'Nell Gwynne Farm and Medmenham Church'. 1944 had a distinctly nostalgic feel with 'Pre-war Sunday in Hyde Park', and the remembrance of that prestigious 1935 trip to Canada and the U.S.A. with 'Quebec from the Ramparts'. With 'Stooking before the Rain' and 'Cornfields in the Thames Valley', Badmin was making an important record, since the sights recorded were to become, in post-war years, increasingly rare.

By the autumn of 1945, it was business as usual for Badmin at the R.W.S., with 'Henley Regatta, 1945'. Over the next three years up to autumn 1948, however, he contributed only five more drawings, a reflection of the great amount of alternative commercial work he had, and the

necessary travelling that was required of him in the post-war years. In 1948 Saxon Artists became his agents and from then on the demands of commercial deadlines never let up. It was not, in fact, until the mid 1950s that he managed again to exhibit at least two or three major works regularly at every R.W.S. exhibition.

One commission in 1944 shows how well Badmin could embellish the world of advertising. The drinks manufacturers Horlicks ran a series of advertisements, illustrated by Badmin, in which the caption had the recurring legend, 'When you find Horlicks difficult to get, please remember that many have special need of it.' The tone of the advertising copy that follows now seems so trite and stamped with self-importance that, after the space of forty years, a laugh must be permitted. 'In emergency rations issued to soldiers, sailors and airmen, Horlicks is an essential item. It was specially chosen for this purpose because it is exceptionally nourishing and sustaining. The makers of Horlicks are proud that it helps save innumerable lives. Large quantities of Horlicks are also required for hospitals, vital war factories, and the mines. This is why there are only limited quantities of Horlicks in the shops. So when you find Horlicks difficult to get, please remember that many have special need of it. And make Horlicks by mixing it with water only. The milk is already in it.'

Badmin's series of drawings for Horlicks, usually on the theme of recuperation of the war-wounded, restored dignity to the page by avoiding the mawkishness of the narrative. With care and, no doubt, an efficiency befitting the uniform, a nurse serves drinks to a convalescent soldier in the

Horlicks advertisement, 1944

When you find Horlicks difficult to get, please remember that many have special need of it

In emergency rations issued to soldiers, sailors, and airmen, Horlicks is an essential item. It was specially chosen for this purpose because it is exceptionally nourishing and sustaining. The makers of Horlicks are proud that it has helped to save innumerable lives. Large quantities of Horlicks are also required for hospitals, vital war factories, and the mines. This is why there are only limited quantities of Horlicks in the shops. So, when you find Horlicks difficult to get, please remember that many have special need of it. And make Horlicks by mixing it with water only. The milk is already in it.

HORLICKS

Sketch for Horlicks advertisement, 1943

Puffin Picture Book cover, 1946

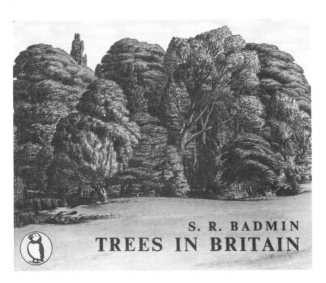

S. R. BADMIN
TREES IN BRITAIN

knot garden of a substantial country house. All is well-ordered and solid, from the regular lines of the balustrade down to the wooded lake, and sanity has at last been restored to the soldier's war-torn world. He leans his crutches nonchalantly against the clipped box topiary, while he helps himself to Horlicks – on this occasion made with milk, one hopes. Only the second nurse in the picture is a puzzle. She returns to the house with a trayful of empty glasses – if this was the first serving of Horlicks to the lone garden occupier, he has a famous thirst indeed. The preparatory pen-and-ink sketch (left) has a rapid evocative strength, which makes it a matter of great regret that Badmin was not an official war artist.

The impact of the covers of the Puffin Picture Books, and Badmin's skill in lithography, were not forgotten during the war years: in 1944 Batsford published *How to study an old church* by A.

Needham. The cover, designed by Badmin, turns a dull title into something inviting. (With brave humour he signed a gravestone in the church-yard.) The following year Van Leer, a Dutch publisher, obtained four litho covers from him for children's nature books. Countrygoer were the next publishers to use his skill for the cover drawing for *In the Autumn* (the seventh Country-goer book). And the final edition of the now famous Puffin Picture Book *Trees in Britain* of 1946 had a new cover, a new title page and additional pages done for the hardback version (below left).

Corporal Badmin's useful contribution to the war was by this time over. For an R.A.F. man there had not been much flying: 'The only time I flew in the war was in a Spitfire going round and round above Farnborough trying to sort out the build-ings.' With the addition of new buildings, the camp at Medmenham had grown to an unmanage-able size, rather like 'Suburbia' without the town planners (or perhaps with town planners). Badmin may not have succeeded in sorting out this R.A.F. 'new town', but he was certainly the right man for the job he was given. From an early age, he had demonstrated his sense of aerial perspective, as shown in the drawing of 'The Road to Worth Matravers, Dorset' (right) completed at the age of 27, in which a pleasing sense of order is brought to the landscape by the artist's simplifying almost to the point of abstraction. In this it reminds one of William Lionel Wyllie's famous 'Aerial View of the London Docks'.

The usefulness of *Trees for Town and Country* gave Badmin enormous pleasure, and the same satisfaction resulted from the drawings he did for Thomas Sharpe's *Replanning of Oxford*. Though

very little became of these plans, the drawings were imaginative in their own right. Badmin selected two for the 1949 R.W.S. Spring Exhibition – 'Christchurch, Oxford, showing proposed re-planning of St Aldates' and 'Merton Fields, Oxford'.

John Murray was the next publisher of renown to line up for Badmin's services and in 1947 *Country Bouquet*, written by Phyllis Nicholson, was published. It is a gentle, chatty, lightweight book, distinguished by the artist's fourteen vignettes. The style was learnt from the days of *Highways and Byways in Essex*, refined and made more gentle and parochial. The chapter headings have a seasonal timelessness that suggests, as in Browning's *Pippa Passes*, that 'all's right with the world'. All the vignettes are small in scale but, taken together, contain much of Badmin's repertoire: January is cold and still, with furrowed fields edged by leafless trees; March is an unconventional still-life of the spring flowers at the Women's Institute; April is a well-ordered farm coming alive, with an old steam tractor pulling down the dead elms of the rooky wood in the distance; May is a profusion of colour around the cottage back door; June is when the hedgerows are at their best (page 10); August is a beach holiday still-life – a wavy, entwined abstract of bladderwrack and sea shells; September is the harvest festival (page 11); and November is a wood-pile stacked ready for winter (page 38).

Odhams Press – with E.J. Embleton (late of the Min. of In.) as art editor – was to be Badmin's main publishing house over the next few years. Starting in 1947, Odhams produced a series of illustrated books of the countryside, culminating in 1950 with the classic *British Countryside in Colour*. As a run-up

to this, in 1947, Badmin produced for Odhams 'Day in the Life of a Farmer'; 'Bird's Eye View of a Farm'; 'Scenery above Soil'; and, as author and illustrator, 'All the Fun of the Fair' (this was published later in 1950 in the *Children's Wonder Book in Colour*).

The *Nature Lovers' Companion* (1949) had three colour illustrations – 'How scenery reveals the nature of the soil', 'Work on the farm in late summer', and 'Work on the farm in autumn'. These three colour plates – plus the many colour plates in *Nature through the Seasons* published the following year, 1950 – were combined by Odhams in a special book as their contribution to the South Bank Exhibition of 1951. Many of them were highly-finished major works, which meant six months or so of hard work, travelling to the places

'The Road to Worth Matravers, Dorset', 1933

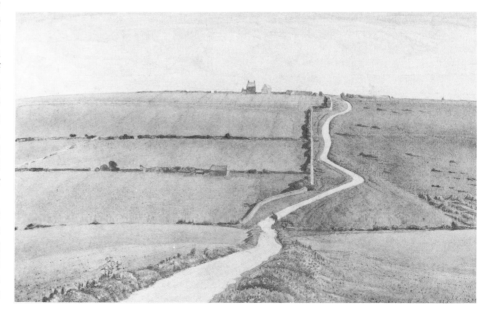

Odhams had listed as characteristic of the British Isles. Badmin remembers it as a happy time, travelling out on the open roads with little post-war traffic. But fine commission though it was, British publishers are not renowned for overpayment of their artists and a small legacy of £500 from an aunt was a welcome addition to the finances of the travelling man.

Badmin reached his deadlines on time and, on the way, got much enjoyment. In particular, he was very taken by Leicestershire, Devon in the area of the South Hams, the Cotswolds with typical villages such as Upper Slaughter and, of course, the South Downs where he has now spent his long and happy 'retirement'.

The increasing popular exposure of his work in this post-war period began to give Badmin almost more work than he could handle. Industry and advertising were beginning to expand, and Badmin's combination of dependability, flair and understanding of the needs of the commercial world made him an obvious choice as artist for many companies. Saxon Artists arranged much of this commercial work in the late 1940s and Badmin regards some of it as good. A series on papermaking for the Bowater Paper Corporation is particularly well designed, with the instructive advertising blurb shaped to mirror the vignetted view of a china clay mine (left). Fison's , the makers of agricultural products, also used Badmin's services well, in a series in the magazine *Farmer's Weekly*.

The 20th century had seen a growth in the tradition of involving the very best artists in designing advertising posters for the London underground and the railways. Clarity of line and a characteristic use of form and colour had pro-duced an art that had great impact on an increasingly mobile population. Over the half-century from John Hassall ('Skegness is *so* bracing') to Stanley Roy Badmin, posters had been designed by men at the top of their profession, such as McKnight Kauffer, Norman Wilkinson, D.Y. Cameron and George Clausen. These last three had also done posters for the London Midland and Scottish Railway, while for the LNER in the late 1940s Badmin was on top form, doing a series of viaducts for carriage posters of Yarm, Welwyn, Berwick-on-Tweed and Croxdale viaducts.

Demands for this type of railway and travel art continued for a number of years. A joint commission came from Chester city and the railways for a poster of Chester in September 1951. Earlier that year a castle poster and a village poster had been produced for British Transport. The following year the British Travel Association requested four posters entitled 'A Village', 'A County Town', 'A Fishing Village', and 'A Cathedral Town'. With Odhams' popular *British Countryside in Colour* coming out in 1951, Badmin was contributing much to images of the country and seaside resorts as places for leisure time. The growing success of the British Travel Association in uniting leisure and travel resulted in a number of bookcovers and black-and-white leaflets for them. In 1947 Batsford managed to get over fifty black-and-white illustrations from the busy artist for the National Trust, and followed on with the *National Trust Guide to Buildings*, published in 1949. The cover to the guide, written by James Lees-Milne for the growing empire of the National Trust, featured a view of Knole in Kent and has kept its look of clear-cut modernity over

Bowater Paper Corporation advertisement

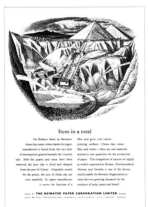

the years (below right).

In 1950 Badmin re-married. His new wife Rosaline bravely and happily took on the upbringing of his two children, Patrick and Joanna, along with that of her own daughter, Elizabeth. Badmin has always regarded Rosaline as a great help in the studio, especially in the early days when his commercial work was always wanted in a great hurry. In 1953, in partnership with her husband, she helped in the development and painting of a large 'Tree' mural, eight feet (2.5 metres) square, in the canteen of a chipboard manufacturer's factory. It gave rise to an outburst of popular art, since a great variety of birds' nests and animals were added by the canteen users.

Another important patron emerged at this time – Royle's, the printing firm and fine art publishers, who became one of Britain's largest manufacturers of greetings cards and calendars. Royle's enjoyed Badmin's art and were increasingly able to see its commercial potential. Since 1945, when the editor of Puffin Picture Books, Noel Carrington, introduced Royle's to Badmin's work, they have evidently taken pleasure in producing over a hundred of his highly-finished scenes of the British landscape. The present managing director of the family firm, Julian Royle, admires Badmin, and possesses several of his finest original works. Access to Royle's files gives one a fascinating insight into the public's buying taste for greetings cards and calendars over the last forty years. There is a recurrent appeal in this archive of the British countryside in all its seasons, and the dated fashions of the 1950s and 1960s apparent in the figures only accentuate further the permanent values of the landscape. As more than half the colour plates in this book show, all are due for revival. The Royle–Badmin team, however, has not always been successful. One special print, done in 1955, was a disaster, despite what Badmin laughingly remembers as its irresistible content – '"St James's Park, Spring" had birds, trees, water *and* Buckingham Palace!'

Badmin's reputation as the specialist tree artist was further consolidated by a commission in 1951 for a book called *Famous Trees*, published in 1952 by The Dropmore Press, which was a subsidiary of *The Sunday Times*. The trees were selected by the Hon. Maynard Greville and the text was written by St Barbe-Baker. The book was brought out in a very handsome limited edition of a thousand, with hand-made paper showing off to best advantage

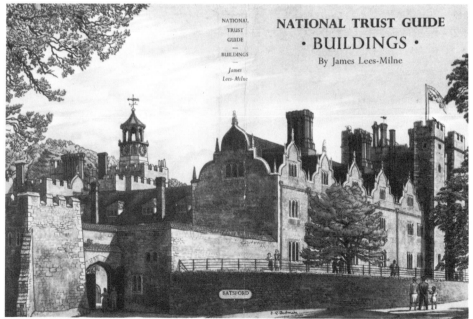

National Trust Guide
dust wrapper, 1949

species of an otherwise extinct race which formed the chief vegetation of the world before the evolution of the familiar modern types. *Trees for Town and Country* tells us that the Gingko Biloba is especially suitable for lawn, town and street – a nice conceit for a prehistoric tree! Its growth is often erratic and ungainly in its early stages and shelter is required if it is to grow into a good shape. The high sheltering walls of Panshanger kitchen garden have obviously contributed to the success of this perfect specimen. But, desirable and decorative though it is, this deciduous delight is not one for the impatient gardener – if you want one over 100 feet (30 metres) or so, you will need to wait at least 120 years. *The Sunday Times* also published these tree illustrations weekly in the newspaper – a fitting degree of exposure for an artist used to mass distribution of his work.

Badmin's definitive illustrations of celebrated trees, done in black-and-white, enhanced with separate printing in light brown. The fine mature walnut specimen chosen from Gayhurst Park, near Newport Pagnell in Buckinghamshire, is at least a hundred years old, according to the scale drawings in *Trees of Town and Country*. A walnut tree of this size is rare in Britain as it is not a very hardy tree in the British climate and is often damaged by spring frosts. It is significant that the specimen stands in parkland, since walnuts like full sunlight, and that the soil in Gayhurst Park is almost certainly a deep light loam over chalk or limestone, since walnuts dislike thin, acid soils.

An even more splendid example was chosen of the Gingko Biloba tree. This intriguing tree, also known as the Maidenhair Tree, was introduced into Britain from Japan in 1730, the last remaining

The successful formula of pen-and-ink vignettes for the openings and closings of chapters was again repeated in 1953 with the publication by Cassell of *The Seasons*, written by Ralph Wightman. Well-known and popular for his regular talks on the radio, Wightman had a great knowledge of the countryside. In this book he recalled life in Dorset, ranging from his childhood recollections through to the problems and seasonal pleasures of contemporary farming. Badmin's ten illustrations exactly matched his tone and recalled the pastoral charm of his etchings of thirty years before. The preparatory drawing for the chapter heading of 'Summer', (shown on the title page) is inspired by Ralph Wightman's evocative paragraph: 'At haymaking time in summer it is good to lie in the shade of the hedge during the break for lunch and listen to that sleepy hum. At least it is good until a vicious ping

stands out from the background of noise and you slap wildly at your neck, where some fragile tiger of the air has drawn blood. Possibly the only justification of a great deal of cider is the thought that if your veins contain enough alcohol it might poison these pests. On the other hand it might only be sufficient to start them celebrating.'

During the 1950s Badmin showed a great ability to illustrate the spoken, as well as the written word, and his many and regular contributions to *Radio Times* added much to the stylishness of that publication before the growing dominance of pop culture in the 1960s and the increasing preference for the televisual image over radio completely changed its look. During the 1950s, *Radio Times* provided a forum for some of the best British illustrative art. 'The Village Green' (below right) shows perfectly the narrative strength and atmosphere that can be achieved with pen-and-ink line drawings. Badmin's sense of design by this time was masterful even in the smallest vignette. In a 1959 illustration, 'Countryside in January' (page 37), we are able to sense the grey, still cold over the land, while the hedge-layering farmer adds fuel to the swirling smoke of a winter bonfire.

Three or four times during the 1950s Badmin did the entire front cover design for *Radio Times*. The final artwork for a cover in 1951 is shown on page 34; Rosaline Badmin did the modelling for the woman shelling and preserving peas while listening to the wireless. Unfortunately, however, a curious piece of BBC editing obliterated this part of the drawing in the published version with a diagonal spread of programme notes. More than thirty years later, we can restore the balance – and guess at the vicarious joy that the artist must have

got from drawing in the distant impromptu football practice.

There has probably never been such a successful and fruitful combination of art and commerce as in the Shell series. Even Pears' soaps cannot claim such penetration into the popular consciousness as this phenomenon of arts advertising and sponsorship. Shell's highly-rated poster series and guides had been appearing since the early 1930s and, in the pre-war days, involved talents such as Clifford and Rosemary Ellis ('Antiquaries Prefer Shell', 1934), Stephen Bone ('The Shell Guide to the West Coast of Scotland'), Rex Whistler ('The Vale of Aylesbury'), Rowland Hilder, Paul Nash ('The Shell Guide to Dorset', 1937) and John Piper ('The Shell Guide to Oxfordshire', 1938).

After the war Shell's distribution increased and its educational impact was made much greater by poster displays in thousands of classrooms, petrol stations, on hoardings and in the up-market 'glossy' magazines such as *Country Life*, *Illustrated*

'The Village Green', 1940

London News and *Punch*. S. R. Badmin's contributions came relatively late, but greatly enhanced the success of the Shell Guide 'look'. In 1955 Rowland Hilder had just completed, in collaboration with Geoffrey Grigson, the *Shell Guide to Flowers of the Countryside*, when Badmin was asked to embark on the ambitious and highly successful *Shell Guide to Trees and Shrubs*. He was, of course, the obvious choice for the project, and produced characteristically inspired work – all to the publisher's deadlines. He remembers it as a very arduous assignment, which fully taxed his physical and mental resources. 'On the Shell series I worked till midnight almost every night and found myself quite unable to work on anything else for a while after the series was over.' The initial working drawing for the April guide indicates the artistic problems of being comprehensive, of including so much and yet trying never to lose the cohesion and overall appeal of the picture (right). In the margins of this preparatory state alone is a check-list of 25 different species that the artist must characterise with distinctive form and colour. Due to its great popularity, the *Shell Guide to Trees and Shrubs* was brought out in book form in 1959.

Badmin's great project for Shell (whose art directors, Jack Beddington and Kenneth Rowntree, had shown themselves to have a comprehensive understanding and knowledge of the art, artists and commercial design possibilities of the day) was the *Shell Guide to the Counties*. He was asked to do five – Yorkshire, Shropshire, Surrey, Middlesex and Hertfordshire, and Northamptonshire.

The working drawing for Northamptonshire (page 36) has the key to his compositional process scribbled in the margins. The proposed content is divided into the industrial side and the traditional side. The industrial side is away to the distant left – 'Corby with its sulphurous smoke and giant bunsen burners; overhead bucket cables converging on Corby; open-cast iron ore quarrying; special iron ore tip lorries; corn crops growing to edge of quarries'. Over to the right is the traditional side – Queen Eleanor's Cross; the spire of a typical church, and Middleton Cheney. Between them are 'fine stonework and carving on church towers and gravestones, fine manor houses, great country houses, and beautiful thatched and stone-roofed stone houses with careless patches of red brick and slate horrors.' The foreground shows ancient and modern boots, a Roman stone coffin, Roman castor ware and Northamptonshire's favourite sons,

George Washington and John Dryden. The powerful mass of Henry Moore's 'Mother and Child' statue in St Matthew's Church, Northampton, is in the centre, but before the final illustration was completed the claims of Yorkshire took Henry Moore and his Madonna on a free transfer to the county guide of his birthplace.

In the splendid 'Landscape in Britain 1850–1950' exhibition at the Hayward Gallery in London in 1983, the choice to represent Badmin was the 'Shell County Guide to Shropshire'. In some ways it was the least successful of the guides and would not have been Badmin's own choice, but then the success of this exhibition was partly due to the idiosyncratic taste of the two selectors, Frances Spalding and Ian Jeffrey. 'Shropshire' did, in fact, prompt the *Observer* critic William Feaver to an assessment of Badmin of great perception. In reviewing that remarkable exhibition, Feaver understood the contribution of this style of illustrative art, which recreates human relationship with landscape by reassembling its constituents into a recognisable but unfamiliar picture. The pleasure in it lies in re-experiencing the memories and associations:

> Clifford and Rosemary Ellis's 'Antiquaries Prefer Shell' of 1934, a poster untainted by any whiff of market research of petrol, ties in with their subsequent dust-jackets for Collins' *New Naturalist Library*, each one an aspect of British landscape – flora, fauna, geology broadly summarised. It also anticipates S. R. Badmin's 'Shropshire', from the Shell Counties ads of the late Fifties. This meticulous little gouache is the gist of the exhibition in capsule form.
>
> Abandoning the Ordnance Survey, ignoring constituency boundaries, Badmin has rearranged the county, bringing all the best bits together. The Iron Bridge at Coalbrookdale now links half-timbered houses, the Long Mynd and the Wrekin. Local products (black-face sheep, a willow-pattern plate) have their place. Portraits of great men – Charles Darwin, Captain Webb – look on. Housman too, of course, and in the foreground, propped up as the vital clue, a copy of 'Comus', the Shropshire masque.
>
> In the 'grots and caverns shagged with horrid shades' of the Hayward – that is to

Working drawing for 'April' in Shell Guide to Trees and Shrubs, *1957*

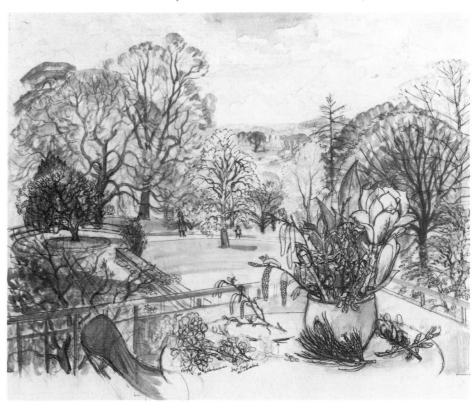

say in galleries where daylight never penetrates – the Cotswolds and the South Downs, Bettws-y-Coed and Loch Katrines are memories of the open air. While they all go to show that 'Beauty is Nature's brag', what is most striking about them is the wealth of associations.

All but one, Northamptonshire, of Badmin's counties survived to be included in a comprehensive and popular book called *The Shell and B.P. Guide to Britain*, produced by the Ebury Press in association with George Rainbird in 1964. Each of the counties was introduced by a travel writer of note, Geoffrey Grigson starting the book off with

Working drawing for 'Northamptonshire' in Shell Guide to the Counties, *1950s*

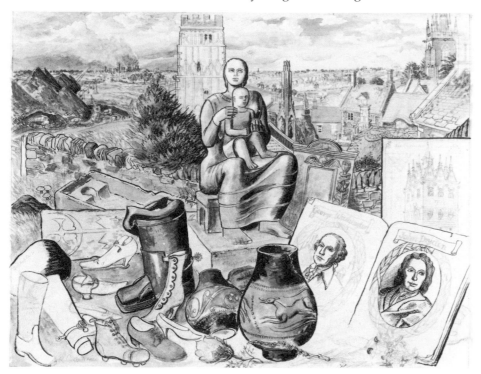

an introduction to Cornwall and the Isles of Scilly. A gazetteer followed so that by the end of the eight hundred or so pages each town in Britain had been covered with some erudition, all the way from Craig-y-Nos to Ecclefechan.

Each county or area had a colour plate, usually taken from the original county series, and the array of talent is a tribute to the concept of the whole Shell enterprise. Among the 48 plates there are five each from S. R. Badmin and Rowland Hilder, three from Richard Eurich, and two each from Leonard Rosaman, John Nash, David Gentleman, Julian Trevelyan and John Elwyn. This book really marked the end of a sustained and enlightened art patronage from the oil companies through advertising. It is said that, after a change of management, Shell's advertising was reassessed and it was concluded that none of this had ever sold one extra gallon of petrol. Market research is a sophisticated tool and it is in any case useless to argue the point, but it was good while it lasted – even if it did not sell any more petrol, Shell's patronage did represent for a while the acceptable face of naturalism.

Since the war all sorts of journals and companies have requested Badmin's services in order to give their images or projects a special 'look'. One of his most interesting tasks was undertaken for the Savoy Hotel in 1957. The designer Henrion, appointed by the hotel as publicity adviser, immediately revamped a suite of rooms and completely redesigned the hotel's brochure, asking Badmin to do a view for it over London from the roof of the hotel. Badmin remembers clearly the experience of going up through the rooms and eventually up a ladder and on to the roof. There

was a 'lovely, healthy wind blowing straight through me. I drew away over several days, doing eight or nine studies and sketches from that view. It was complicated by having to look in three different directions at once over the Thames with its nine visible bridges, and I remember I squashed up the curve a bit.' On one particular afternoon he felt in need of refreshment and climbed down the ladder to ask the hotel staff if he might have some tea or coffee. They agreed to this and said they would send it up. Half an hour later what appeared to Badmin to be the oldest waiter in the hotel came laboriously climbing up the ladder, balancing on one hand a full tray with a 'wonderful display of cakes, tea, milk and sugar'.

The finished watercolour was a very successful double-page panorama of London, which was exhibited at the Royal Academy in 1957 and later published as a greetings card. Though it was a very fine work, it was eventually sold by the hotel, which has since also lost the preparatory sketch, which was stolen from one of the walls.

In 1959 the Badmin family moved to the depths of the countryside near Pulborough in West Sussex, and in that area they have remained. It has been a happy 25 years with the artist's love of the countryside indulged to the full. His passion for gardening has flourished, and the garden has matured with interesting shrubs and plants to be seen in it, like the details in a Badmin watercolour. The four children have all grown up and left, but they regard the house, Streamfield, as a base to return to often, along with their own children.

S. R. Badmin continues to work daily in his first-floor studio, trying to respond, though now with moderation, to the demands of a full order book. He remains a keen supporter of the Royal Watercolour Society exhibitions, but now the demand of other commitments deflects him from producing the full quota of works that would be bought eagerly by a growing number of collectors. He will now avoid large commissions and their associated arduous deadlines if he can, although in 1983 he did undertake a gruelling task of four large plates of designs of the seasons for a U.S. ceramics firm. The works turned out to be of great colour and beauty, but the toll taken in terms of time, energy and family life makes it unlikely that such a scale of commission will ever be attempted again. Other work tends also to suffer during such a time, and the exhibitions at the R.W.S. and the Society of Sussex Painters would not be the same each time without a few gem-like Badmins in one corner.

The artist travels little nowadays, the changing moods of Sussex satisfying his need for new artistic stimuli. He occasionally visits London to attend a R.W.S. function or to deliver the artwork for a

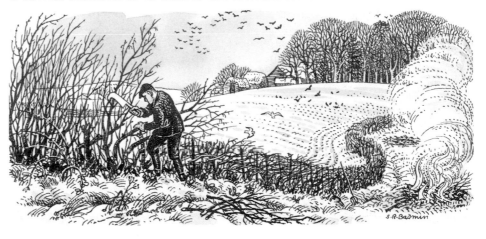

January hedge-layering,
Radio Times

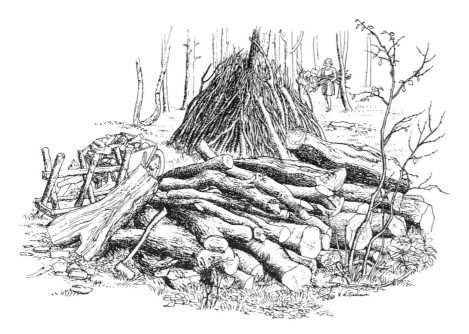

Royle's card or a *Reader's Digest* cover, but returns with happy relief to his beloved Sussex. Although Badmin the artist has always understood urban and suburban life, it is in the seclusion of the village and the family that he finds contentment.

Made an Associate of the R.W.S. more than fifty years ago, Badmin was honoured in 1984 with a small subsidiary exhibition in the R.W.S. Autumn Exhibition. A few selected pictures from private collections were on display, along with the artist's sketch books and books that he had illustrated. In addition, his exhibit of that year – 'Countisbury Hill' – was used on a full-colour poster, celebrating the R.W.S.'s 300th exhibition. Badmin regards the rapid growth of interest in his work to the point where he is now the society's most popular water-colourist with quiet pleasure, but with a degree of circumspection. He is all for the quiet life, and has anyway seen applause come and go before when he received enthusiastic notices in all the news-papers throughout the 1930s. The passing of time quite often enables a surer reassessment of an artist's importance to be made, and Badmin's present high reputation is likely to endure.

In the last biographical assessment to be made of him in the 1962 *Old Watercolour Society Club Volume,* the Editor, Adrian Bury, wrote: 'Roy Badmin who lives in this ideal old house in an ideal setting must know this mood of *continuity* for it is so much part of his philosophy.' Adrian Bury was obviously affected, on the afternoon that he went to inter-view the artist at his house in Bignor, by the con-templative feelings that the history and lines of Sussex can suggest. Much of his article has this pleasantly elegiac note and looks at the same qual-ities of timelessness and value in long descriptions of fine selected works by Badmin, such as 'Snow on the Downs', 'Ludlow Castle', 'Richmond, York-shire', 'Dover, Evening' and 'The Park from the Library, Hovingham Hall, Yorkshire'. The view up to Bignor Hill with its ever-changing light can affect the visitor like that – and in the presence of such friendly and cosy hospitality Stanley Roy Badmin's benign taciturnity can easily make one look to the studio window to find the lyricism of the English landscape.

Technique and inspiration

In 1930 the critic from *The Times*, reviewing the first one-man show of S. R. Badmin at the Twenty One Gallery in London, attempted to identify him amongst a group of 'young artists who are turning back to the land in a more special sense than would be conveyed by saying that they are landscape artists. They find inspiration in the facts of agriculture. What makes the movement interesting at this time of day is that it is a young one. That it implies some weakness of the designing faculties is likely enough, but it suggests also a certain "fed-upness" with the pretentions of their slightly older colleagues, as if the young artist said, "Well at any rate we can try to draw what is going on around us".' In seeking the general point, the critic hinted at a particular quality of attitude and life-style that was to distinguish Badmin at an early age and that set him apart from the mainstream of the land-scapists of the 1930s and 1940s.

Though his vision at an early age was a traditional one, it contained no hint of nostalgia. He was already observing closely and lovingly all that lay around him and recording it with a fine and poetic perception. His early etchings, drawings and watercolours are all rooted in the 'here and now' and touched by human qualities. His vision was not a selective one, since it contained the realism of the working landscape, full of the sounds of farm machinery and the toils and plea-sures of village routine. There is no looking back to a previous age in his pictures of the rural environ-ment – they are real and if, at times, they look idyllic it is not with the tranquillity that comes from an unruffled and unimagined age, nor from any dislike of what is around him. Badmin's land-scapes are always seen in the context of a worka-day, sociable and intimate life-style that is far too involved in country routine to hark back to an age of lost innocence before machinery, railways, roads and a population on the move.

Badmin himself has always sought enjoyment and peace in the landscape and looked to it for the subject matter of his art. He has never regarded it as a place for soul-searching or communing with nature on wild hillsides, nor has he sought to put modernist methods of art and expression into a landscape form. Landscape, quite simply, has been Badmin's context. He is happy in it, having found a successful and satisfying style with which to record it. He has not sought to change the repu-tation he built up; indeed, he has responded posi-tively to all requests by commerical companies to re-create it.

It is this complete lack of self-consciousness that distinguishes Badmin and his art. With his taste for reality he has put colour, vigour and detail back into the Royal Watercolour Society exhibitions at a time when, apart from the work of a few painters, they were lost in thin and vapid genuflections in the direction of the Old Master watercolours. Badmin's success in illustrative and descriptive art defies the sort of scholarship that is merely the

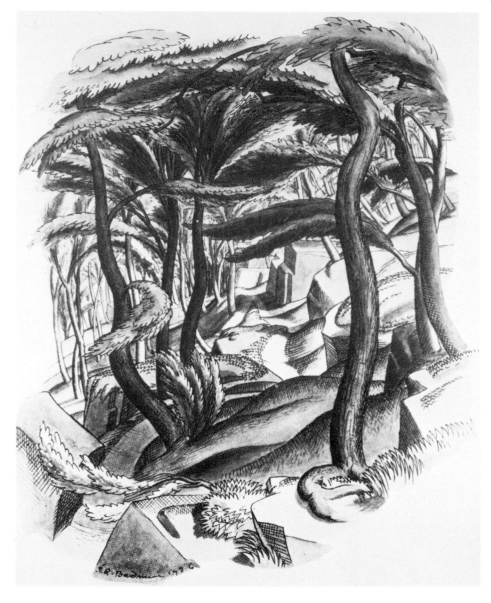

empty stylishness of academic criticism. The dry opinions that lost the joy of 19th-century art in the post-war deliberations of fashionable cliques have never touched Badmin. He had work to do – and when it was done the public liked it and bought it.

In his return to the land, Badmin further distinguished himself amongst other artists after the first world war in happily accepting the company of that new arrival, suburban man. In this he set himself apart from the mainstream in artistic attitudes, and added a peculiar charm and reality to his pictures by his ready acceptance of modern society. Though he rarely painted the industrial landscape, he was always happy to record its immediate consequence, suburbia: for most of his life he lived in it and understood its need for the countryside. There is, after all, no difference between the family trips to Somerset he made in his childhood and the travelling he did in the side-car with his father sketching in his youth, and the hundreds of day-trippers that went down the arterial roads or filled the railway carriages to the seaside. The intention is just the same – it is simply a question of scale.

Badmin celebrates the liberation of all classes of the 20th century. The culture of roads, railways, light industry and leisure was embraced by him, since it facilitated enjoyment of the countryside. Hiking and travelling by car, bicycle or railway provide an anodyne, a relief for the city-dweller or even the day-tripper: railway excursions and trunk roads therefore bring a new reality to Badmin's countryside and people it with gentle souls. Out for a day of swimming, hiking, picnicking or walking, they are the suburban middle classes on the move.

Badmin has become a socio-economic historian as his characters join country people in an art that has become domesticated, familiar and modern. And when the holidaymakers have returned to town, the artist is left to record the activities of the real country folk. When not working on the land, tending their livestock, or looking after their machinery, they take their recreation, mix in market places, watch the hunt, or even have ploughing matches. And little humdrum activities add detail to any landscape and enhance it: in a Badmin work people are feeding the birds, arranging flowers, watering the garden, riding horses, swimming in the river, skating on the frozen pond, playing at snowballs or walking the South Downs Way.

Conventional criticism might have us see in this sort of art just a 'safe and sentimental, view-admiring, country cottage-taking romanticism' (William Packer). But to dismiss S. R. Badmin as merely a romantic detailer is to miss the point. He does not strain after novelty, but it is unjust to see him as literal and unstimulating. His work is a celebration of what the poet Ivor Gurney called 'the dearness of common things'. Badmin does not simply 'record' the landscape, he does not merely produce lucid panoramas for mass consumption, he *intensifies* the viewer's experience of the countryside by imparting to it his heightened vision of the accuracy of things. His is not a vision of Arcadia because there is real work to do in the fields, and men and machines go to it in all weathers.

Though Badmin holds up a picture of the world which we can identify with and love, it is not the sort of representation that a camera might produce. Each painting has a classic structure and design; each in seeking tight linear details has discarded some and chosen others in seeking out the underlying forms of the landscape; each can conjure up the words of the combative Whistler: 'To say to the Painter, that Nature is to be taken as she is, is to say to the player, that he may sit on the piano.'

A Badmin painting may have the tightness and brightness of a Pre-Raphaelite work, but it will almost certainly remove the devotional attitude. Some, however, have been left with just a touch of mysticism or a frisson of something strange – rarely does a picture go further than that and seek a sublime effect. Badmin's men and women are small and slightly vulnerable-looking; their world is that of Philip Larkin's 'Church-Going': 'Hatless, I take off my cycle-clips in awkward reverence.' The force of nature in these watercolours is not that of the sublime, but to be found in the endless and ever-changing seasons, which can obliterate and change man-made artefacts with snow, erosion, flood and wind. A similar thought may have occurred to Adrian Bury as he mused on the greatness of the Roman civilisation when he caught sight of the paltry remains of a Roman villa near Badmin's village home. This sense of the importance of time may explain the artist's acceptance of the changes to society in his own lifetime. The only real fear that can remain is that of war; along with other artists between the wars, Badmin consistently railed against its danger and his days in the Artists' International Association were an important part of his awareness of man's relationship with nature.

An artist can always negotiate with nature in terms of skilful design. Stanley Spencer's words

'Yorkshire Wood', 1936

*Preparatory drawing for
'Westerham Mill, Kent', 1934*

all, rhythm is always important to his design. This 'flow' that he always enjoys in a picture he found at an early age in classics of art. In his home hangs a Botticelli reproduction and from this he can learn about rhythm. Even when his pictures come close to abstract art he tried not to lose this rhythm and will attempt to match geometrical solids with comparable shapes in nature, such as in 'The Road to Worth Matravers' (page 29), 'Yorkshire Wood' (page 40) or indeed in his one and only painting that he thinks recalls the shape of both Cotman and Spencer, 'The Weekend Pass' (page 25).

In 'The Weekend Pass' Badmin's strength of design accentuates the rhythm of the picture, which in turn emphasises the buoyant feelings of liberation that are the essence of the work. It is regrettable that he did not do more oils to develop this sculptural geometry that could so easily have become part of his repertoire. A well-known feature of his watercolour work is to crowd detail into a small space and yet not produce a cluttered feeling – to avoid that uncomfortable sensation, sometimes felt in the work of miniaturists, is a rare ability on so small a scale. The air and space that is left in a tight Badmin design is a consistent quality. Time and again in his pictures we notice at a glance the unity of effect and the overall feeling, and only then marvel at the bright, complex and animated detail.

S. R. Badmin freely lists the influences that he has felt on his work, but finds it difficult to recognise their exact point of contact with him. Matisse, Ingres and Degas are important to him; a Breughel hangs in his studio. Rowlandson must have added to the lessons he learnt from his first two teachers, Cosmo Clarke and Thomas Derrick. Clarke's

may be recalled: 'Intention was to assuage a longing to be associated with nature'. Spencer's vision, however, was a 'childish' one that simplified and dismantled structures like toys; Badmin's is an adult one that does not hark back to the ways of childhood. His alternative method of seeking the truth of nature is to study carefully nature's basic components, and then to transform the scene into an overall pictorial effect by adding the complexity of such detail to an underlying order. In a Badmin picture the masses do not juxtapose vividly, for nature is regarded as tonal and, above

famous oil painting, 'The Country Fair', has in its figures an earthbound bustle and charm. Thomas Derrick directed Badmin to subjects around him, and from suburban Sydenham to central London (right) he observed humanity at work and play. On looking at the preparatory watercolour for his diploma work for the R.W.S. (left), one can understand his affinity for both Francis Towne and Peter de Wint.

Adrian Bury described Badmin's work as 'elegiac tranquillity and beautiful arrangement of light and dark shapes, simplified trees and placid river'. Had there been no Albrecht Dürer, perhaps English watercolours might have looked different and Badmin acknowledges his debt to Dürer both in drawing and in etching. Robert Sargent Austin, Malcolm Osborne and his admired friend P. F. Millard were important to him in his developing years, and fellow-students at the Royal College of Art, such as Edward Bawden, and fellow-artists over fifty years in the R.W.S., may well have helped him as he did them.

S. R. Badmin has never been a 'clubbable' man; the regular social gatherings of fellow-artists have never greatly interested him. As a member of the R.W.S. he has readily attended meetings, voted dutifully and always been ready to express a view on the changing affairs of the society. The demands and involvement of holding office, however, have never attracted him. Even at art school he got his head down and worked hard throughout the day and often in the evenings too. Few of the friendships he made in those early days have persisted. The relationships he later struck up with fellow-artists, such as Charles Morris and Arthur Henderson Hall, he has relished and is now saddened by their deaths in recent years. The overall sustaining force in this artist-craftsman's life, however, has been the love that comes from a secure and close-knit family.

Hard work and application have characterised his work pattern, which continues still on a daily basis, but manual labour alone is not enough to produce art that is special, that appeals to something essential in millions and that is touched by genius. These millions will continue to buy his pictures, read his books and look for his paintings

'Sotheby's', 1933

43

Building a hay rick, sketch and watercolour

on cards. The basic appeal of the unspoilt values of the British countryside is there in them all, and thoughout them human figures are usually involved in some way. Those figures may fix his paintings in time and to some of them they have given a 'dated' look, but this is far from the false nostalgia of frock-coats, post horns and frosted bow windows that belabour us each Christmas. Those details recall an age – if indeed it ever existed – to which we cannot truly relate as we have no experience of it. Dickensian myths have a quaint and cosy appeal, but taken in large doses they are a pointless sentimentality. Most of the Victorian public were unable to go into the countryside to seek pleasure for themselves, but in post-war Britain we have not been so restrained – in Badmin's work it is this generation that recognises and loves a countryside that it has actually seen and felt. The Badmin view is a point at which leisure and art, contemporary history and social manners all meet. Life in this way is experienced through art, as the record of our sensations, and is touched by the genius of the artist who shared them.

A master-etcher

Just as the watercolours of the young Badmin were an immediate financial and critical success, so too were his etchings. In 1928, Robert Sargent Austin introduced his twenty-year-old protégé to the Twenty One Gallery, the leading dealers in the then vibrant etching market, who were well-known as the publishers of the etchings and engravings of Graham Sutherland, Paul Drury and Robert Austin himself.

S.R. Badmin's catalogued list of etchings for that year shows that he had only six completed plates published – all etchings. Etching has always been Badmin's preferred method of intaglio printmaking – that is, the technique where the paper receives the ink from incised lines in an artistically-worked metal plate. In the case of etching, these incised lines are achieved by the biting action of acid on the metal. The design is not drawn directly onto the metal surface, but into a wax composition film or ground that covers the plate's surface, protecting all of it but the parts where lines have been scratched by the etching needle.

On Saturday 11 January 1930 Badmin had his first one-man show at the Twenty One Gallery. He showed eleven more completed etchings, bringing his total to seventeen, along with one line engraving, 'Suburbia', one aquatint, 'Shere, Surrey' and a trial state, 'A Passing Storm, Pole Hill'. This was the output of a successful and hard-working artist, and these were good days for him, with his etchings selling well at between two and five guineas each, and his watercolours at that time making from four to eighteen guineas.

Adrian Bury, always of the *mot juste*, summed up with accurate hindsight in his article of 1962 that first exhibition success: 'At a time when art criticism was intelligible and *responsible*, Badmin's work evoked a chorus of praise from writers able to distinguish between what was serious and permanent and what was nonsensical and ephemeral. The next year Badmin took his place as an Associate of the Royal Society of Painter-Etchers.' *The Times* critic was wholehearted, but restrained: 'Probably the purist would say that Mr Badmin's drawing is not more than descriptive, but it is intelligently selective and so delicate and precise that it gives a great deal of pleasure. . . . Mr Badmin's talent seems to be for line rather than tone, but the etching of "Coleford, Somerset" is finely dramatic in a painter-like way.' And from the *Morning Post* came a declaration of a critic who was clearly much impressed, though tempered with over-seriousness: '. . . He cultivates his technical powers to enable him to attain high excellence. . . . His outlook is sincere and intimate. However so humble his subject may be, he is not content with the superficial knowledge of its qualities, and once he has dug below the surface, he strives to represent appearances, and (still more important) tries to account for them and their beauty and comfort, their serenity and humour. Look at "Suburbia", conditions of life and states of

SUBURBIA

mind could not be better expressed than they are in this delightful drawing. The scene is simple, ordinary, but it is dignified by seriousness and exhilarating light so happily suggested by the artist.'

For 'Suburbia', Badmin made a good choice of line engraving, a technique in which a small metal rod with a sharpened end (a burin) is used. The work is certainly more humorous than serene, and the burin has given it a clean, crisp look quite in keeping with the roly-poly pace of this Heath Robinson-like fantasy of suburban life. This fond caricature says much of Badmin, who was to spend the next thirty years in or around the leafy suburbs of London SE23. His tolerance and acceptance of the lot of 20th-century man (who is never far from the motor car and railway, road and factory floor) singles Badmin out among the other landscapists who brought the beauties of the land back to suburban man. With the help of mass communication Badmin, more than any other illustrator, enticed him out again and down the arterial road to experience it all for himself.

To be made an Associate of the Royal Society of Painter-Etchers (the R.E.) at the age of 25 was a great achievement for S.R. Badmin and in the first R.E. exhibition in the winter of 1931 he made his mark. The critic from the Manchester *Guardian* was quick to note him: 'It is rarely that the Society welcomes a newcomer of the quality of Mr S.R. Badmin, whose four contributions take rank at once with remarkable gifts in draughtsmanship and design. His weakness at present is the natural one of losing himself in his own gifts, but mastery of them will come later with more experience of results. "Dulwich Village" and "Burford" are fine

things with which to begin a reputation.'

Considering the success of 'Suburbia', it is a pity that Badmin did no more line engravings, and interesting to speculate why. It was, after all, the preferred method of his mentor, the assiduous Robert Sargent Austin. The years 1930 and 1931 were just about Badmin's best etching period, with his craftsmanship coming closest to the idyllic and poetic vision of the English pastoral tradition. His subject matter in these years was more suited to the etched line than to the engraved line.

After so much time has passed, Badmin himself now finds it difficult, in retrospect, to sort out how much he was being influenced by any one person or movement. Certainly Robert Austin must be counted as important and Malcolm Osborne, head of the engraving and etching school at the Royal College of Art, is remembered as a very good draughtsman. Badmin also had much reverence for Frederick Landseer Maur Griggs (1876–1938) and admiration for Drury and Sutherland at this time, yet he feels that he was working very independently and deciding his subject matter and technique in his own way. *The Times* critic, reviewing the 1932 Winter Exhibition of the R.E., comes closest to tying together all the threads of etching during these years by stressing three common ingredients – design, craftsmanship and romance:

> Every kind of engraving means a certain amount of manual discipline, which is a good thing in itself, and it also conduces to dwelling upon a design rather more than is common in drawing. Certainly this exhibition is primarily one of craftsmanship, rising here and there to a high degree of virtuosity . . . but it does seem to be the case that some of the most satisfying English engravings, particularly etchings, fall into the class of romantic illustrations, as if his interest in craftsmanship caused the artist to brood upon the subject with a desire to get out of it all that it contains of poetical suggestion. One might almost say that Samuel Palmer invented the type of the best English etching. The most accomplished contemporary artist in the kind is Mr F.L. Griggs RA who does not exhibit this year, but 'Potato Clamps, Kent' by Mr S.R. Badmin is a characteristic example.

Two years previously, in April 1930, Malcolm Salaman, editor of *Fine Prints of the Year* and the authoritative voice on etching, had linked Badmin and Griggs in an unusually succinct article, 'A chat to the print lover', in *The Studio*: 'Mr S.R. Badmin flourishes at the Twenty One Gallery and I imagine this well-ordered etching of Shepton Mallet would win him the benediction of Mr Griggs.'

Though Badmin himself can be considered at this time to have been a lone worker, it is worth looking at the Twenty One Gallery group – Graham Sutherland, Paul Drury and Robert Austin – and tracing some of the influences of that time in British etching. Malcolm Osborne had taken over etching at the Royal College of Art from the great Frank Short when he retired in 1924. Short continued as President of the Royal Society of Painter-Etchers; his term spanned both the boom and the decline in etching between 1910 and 1939. Osborne had himself been Short's pupil at the Royal College before going on to teach at Goldsmith's College, where his pupils in turn were Graham Sutherland from 1920 and Paul Drury in 1922. Stanley Anderson (another former pupil of Frank Short) was also

'Suburbia', line engraving 1930 (original measures 11 × 9cm/4⅜ × 3⅝in)

47

on the staff of Goldsmith's at this time and remained there after Osborne had departed for the Royal College in 1924. Robin Tanner joined Goldsmith's in 1927.

In the mid to late 1920s, then, Tanner, Sutherland and Drury were greatly influenced by the continuity of technical discipline represented by Frank Short, Malcolm Osborne and Stanley Anderson, but the group of young etchers also came increasingly to admire the etching style and vision of Samuel Palmer. Graham Sutherland remarked on the new experience of the 'complex variety of the multiplicity of lines, that could form a tone of such luminosity' and the completeness that was 'both emotional and technical'. This is the 'intricate beauty' to which Samuel Palmer himself referred, and this use of the intricate tone process to produce an effect was the basis of Griggs' work, albeit touched in his case by the restraint of medieval gothicism.

Griggs successfully antedated and, to a certain extent, probably influenced all the Palmerites. Between 1915 and 1920 he was already a great success at the Twenty One Gallery and Colnaghi's then published his works during the prosperous days from 1921 to 1929. One of his etchings, 'The Almonry' (1926–27), made the astonishing sum of £135 at auction.

S.R. Badmin is often linked in technique and subject matter to the Griggs tradition, but in some ways he is closer to the primitive vision of Samuel Palmer, since his etchings are more deeply rooted in the earthy humanity of the countryside. Kenneth Guichard, in his splendid volume *British Etchers 1850–1940*, suggests, interestingly, that it is F.L. Griggs' spirituality (described as an austere medieval Roman Catholicism) that inhibits the human warmth that is the essence of Palmer's work. This difference can also be seen in the pen-and-ink illustrations to *Highways and Byways in Essex* published by Macmillan in 1938. Started by F.L. Griggs, this was the last of a prestigious series of nineteen *Highways and Byways* begun by Griggs for Macmillan in 1900. Due to his illness and death, the Essex volume was finished by S.R. Badmin. The 73 illustrations are more or less equally divided between the two artists, and the differences are striking. Strong in linear detail and architectural design, F.L. Griggs only occasionally involves many figures in his work; S.R. Badmin's, on the other hand, are rarely without – as, for example, in 'The Village Stocks at Havering-atte-Bower'. There is a strange, stark timelessness in Griggs' work, while Badmin's peopled drawings give life to village green and country seats alike – even in 'The Churchyard at Wendens Ambo' (page 50) he has shown old ladies with handbags and hats putting flowers on the gravestones. This early example of purely illustrative work establishes that unaffected and inviting quality that marked Badmin's later topographical and travel books.

At the start of his career, Badmin the craftsman was thinking hard about the use of the medium. Etching rather than engraving suited his contemplative, painstaking approach and with it he could eventually achieve all that he planned with his brilliant design sense. He would like to have done more engraving, but found it hard physical work: 'I found it a terrible strain – you don't scratch with the burin, you have to push, push against the copper, and it is a motion against yourself. Some people use it almost as quickly as a

pen, but it is a terrible strain particularly if you are trying to do a curve, then it's quite a strain on both arms.'

From 1930 onwards time was running out in the etching market; for a young man keen to establish himself and earn his living some of its time-consuming limitations had become apparent. It was at this point that an innovation occurred to him that could save time, since '. . . all the stopping out on various parts, for someone who was very good on trees at this time, I found very laborious.' Badmin's peculiar sensitivity for trees was already noticeable. In 1932 *The Sunday Times* critic mentioned that his watercolour of Clapham Common was 'distinguished by the delicate drawing of the bare trees'. As early as 1930 the *Morning Post* reviewer had seen that 'the linear beauty and significance of trees in winter are revealed with eyes sensitive to the subtleties of form and a hand in sympathy with his sight and mind.'

The 'teasing and temper-trying yet fascinating copper', as Samuel Palmer described it, was usually worked on from the lightest line scratched in the wax on the copper plate to the darkest line – that is, the line that had been bitten longest and therefore deepest by the acid. To prevent the lighter lines continuing to bite, they had to be 'stopped out' with Dutch varnish at each stage. S.R. Badmin began to use a method that, with thought and planning, could shorten the tedium of so many stages. 'I developed the idea of etching the dark parts first – etched, put it into the acid bath for twenty minutes, then on to the part which was not so dark, draw it, and put it into the bath for another twenty minutes, then five minutes,

three minutes – this all added up to about ninety minutes for the darkest part. No stopping out, cross-hatching – all of a very subtle nature. As I went along, fine lines added to the very dark design.' This was a reversal of the usual method, and it did cut down on the succession of stopping out. 'Dutch varnish', remarked Badmin, 'was horrible to deal with.' His method did, however, require a very clear design right from the outset: 'My way required a very well thought out drawing. So you had to work out a timetable of drawing and scratching out of the lines which you required to etch.'

In 1931 what is probably Badmin's favourite etching was published – 'Swinbrook Bridge'. The impression shown on page 54 is a trial of the seventh and final state on Dutch laid paper. 'Dutch laid is when you get wire watermarks – quite a nice paper. I used to try out papers as I worked. In this case I did put a lot of ground on and further etched. . . . I spent a long time on this one and this I think must be the finished stage, but I think I would have burnished this on the rain and sky because, on looking at it now, it looks a bit too flat and even.'

Burnishing is a process of pushing in the edges of particular grooves so that they take less ink. It is done at a late stage, directly onto the plate surface, and is a way Badmin had of reducing the dark effect of close-etching and cross-hatching. 'Tones are adjusted with that – it is a reducing process, used a lot when doing mezzotint.' As in mezzotint engraving, burnishing is, in effect, a process of going from dark to light; the opposite of this in the final touches of printing is the process of soft, inky enrichment called retroussage. Retroussage was

Architectural study in Thaxted, Highways and Byways in Essex, *1938*

used often by Badmin – his technique was to pass a fine muslin cloth over the surface of a plate after it had been inked and wiped. The cloth took up tiny amounts of ink from the etched grooves upwards to the edge, so removing some of the sharpness of the line on printing. With hindsight, Badmin feels that there may be a little too much retroussage in his etchings. He enjoys the cleaner, even look of another printer's work in 'Priory Pond, Stroud' in its second edition of 1981 (page 58). Samuel Palmer's thoughts on the technique in general were emphatic: 'It seems to me that the charm of the linear etching is the glimmering through of white paper even in the shadows, so that almost everything sparkles or suggests sparkle. Retroussage, if not kept within narrow bounds, extinguishes the thousand little luminous eyes which appear through a finished linear etching.'

'Swinbrook Bridge' came just about half-way through Badmin's all-too-short etching career, and was the first to be illustrated in *Fine Prints of the Year*. The editor was unreserved about the originality of its content: 'Mr S.R. Badmin is forming a style of his own which promises to make him distinctive. His "Swinbrook Bridge", sketched in the transient light of a passing storm with troubled waters eddying vividly about its stone piers, shows a fine old rugged picturesqueness, enhanced by the jolting cart on the rough road, the delicate lines having an exquisite pictorial significance.' Due to its vigour and inventiveness, it is certainly an image that has endured. When shown by Ian Lowe, Curator of the Ashmolean Museum, Oxford, in a lecture to the Print Collectors' Club on British etchers at the Conduit Street Gallery, it stood up to being enlarged twenty-odd times – and received a spontaneous round of applause.

Another demonstration of Badmin's fine workmanship may be seen in 'Fallen Mill Sails', also published in 1931, and 'Evening Light near Sevenoaks', published the previous year. 'I used a traditional sky, horizontals – very difficult to do, very fine lines, very close together. Very neat. Working this through a little layer of wax you have to be very careful.' The danger of such close work is that the wax between the lines might crumble, allowing the acid to bite through between them. This dread disease, known as 'foul biting', has here been successfully avoided by the artist. 'Evening Light' went through six states: 'I think I would have added one or two horizontals in the sky.' Beyond that, it is hard even now to see the difference between the final and, say, the third

'The Churchyard at Wendens Ambo', Highways and Byways in Essex, *1938*

state without the hints Badmin wrote at the time on one of the final additions: 'Sky refined, roofs worked on, sun touching tip of branches.' The impression shown on page 53 is taken from an artist's proof. His subtle refinements now inspire admiration – probably ecstasy in an obsessive philatelist – but all the states are pleasing and successful images.

Though Badmin's output was falling in 1932, three prints of that year are among his best. 'Mill Street, W.', illustrated in *Fine Prints of the Year*, shows the artist taking in a folio of new work to his publishers at the Twenty One Gallery whose sign, 'XXI', can clearly be seen. This part of Mill Street in the West End, with Savile Passage straight ahead, was bombed during the second world war and has since been rebuilt as a continuation of Savile Row. Malcolm Salaman, still editor of *Fine Prints*, was by now the arch-priest of the etching religion, albeit with a dwindling number of disciples. He wrote in 1932: 'Mr S.R. Badmin etches in his own way, his subject matter deciding his style. For instance, "Potato Clamps" and "Priory Pond, Stroud" claim a rustic style which appeals quietly, but for "Mill Street, W." he has an urban manner, almost metropolitan, for the place has a peculiar charm of its own; it is not a thoroughfare, and its houses and shops are all different. To a Londoner it has a peculiar charm, for it suggests a London that lingers in places, but it is alas dying away. In a corner is the Twenty One Gallery but it does not attract the only visitors, for there are busy shops and the sun shines graciously.'

Badmin published no new prints in 1933 and his otherwise successful exhibition at the Fine Art Society in 1933 sold only two prints. *Fine Prints of the Year* lists 1934 as barren, but one print, 'Wareham, Dorset', was produced for the Print Collectors' Club. On the final state, the club's well-known monogram, 'P.C.', was inventively inserted above a tiny 'S.R.B.' and '1934' on the hanging board of the shopfront. The edition of fifty was printed commercially by the club. The resulting uniformity, it was felt, would reduce any squabbling over minor changes that might have been made by the artist during printing.

Three prints were done in 1935 and two were published – 'Richmond' and 'Cheyne Row'. The latter was illustrated in *Fine Prints* where Salaman gave it an approving grunt: '. . . a style of its own gives distinction to S.R. Badmin's "Cheyne Row, Chelsea".' He is right as always since it is, for an etching, unusually full of imaginative incident and narrative content, presaging the illustrative style Badmin first used so successfully in *Highways and Byways in Essex*.

At this stage, Badmin forsook etching for illustration, because etching sales were negligible, and the artist was primarily interested in earning a secure living for his family. 'People here did not realise what the U.S.A. crash was like,' he avers, but of course many did and literally millions of people changed direction in their lives as the etchers of the 1930s had to do. If there had been no stock market crash one wonders whether S.R. Badmin would have been content to continue etching, in agreement with the view of Samuel Palmer, who wrote to the critic P.G. Hamerton that if etching had been reasonably remunerative he would have been 'content to do nothing else'. Palmer liked the technique in its own right because it had 'all the excitement of gambling without its

**Shepton Mallet,
Somerset**, 1930
(etching in an edition
of 50)

guilt and ruin.' Badmin, however, was a much younger man than Palmer when he started etching, and he was not in need of such occupational therapy. Had he been born ten years earlier, perhaps he would now be regarded as one of the great British etchers. When he hung up his needles and burin in 1936 after producing his last etching, 'Oxfordshire Cottage', he had had only eight productive years, but they had produced a distinctive oeuvre full of interest and small-scale fascinations.

More than that of most pre-war etchers, Badmin's work has suffered from a case of neglect. But now that the 1970s and 1980s have got etching over its Rip van Winkle days it is easy to agree again with Palmer that 'a moderate Capitalist might get some pickings out of us if he had the wit.'

The critic Herbert Furst in reviewing a book of original engravings and etchings for *The Bookman* of autumn 1931 saw the essence that lay within each of Badmin's etchings when assessing 'Shepton Mallet'. In displaying his own critical creed, he also indicated why S.R. Badmin, only 25 at this time, was to distinguish himself over the next fifty years as something very special in British art. 'Mr Badmin's etching', he wrote, 'betrays in its every line and more in its supplementary figures, a love to which it owes its existence; and that is not the "love of art" but the love of life which seeks and finds expression through art. Ultimately that in my view is not only the test of "quality" but the source of all true inspiration.'

The etchings on these and the following pages are all reproduced in their original size.

Evening Light near Sevenoaks, Kent, 1930 (etching in an edition of 40)

Swinbrook Bridge,
1931 (etching in an
edition of 45)

54

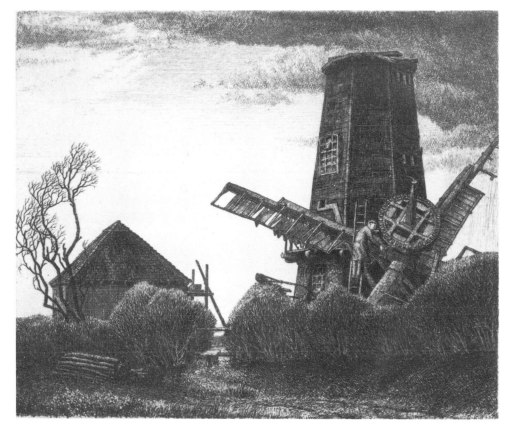

Fallen Mill Sails, 1931
(etching in an edition
of 35)

Right
Richmond Bridge,
1931 (etching in an
edition of 50)

Far right
Potato Clamps, 1932
(etching in an edition
of 25)

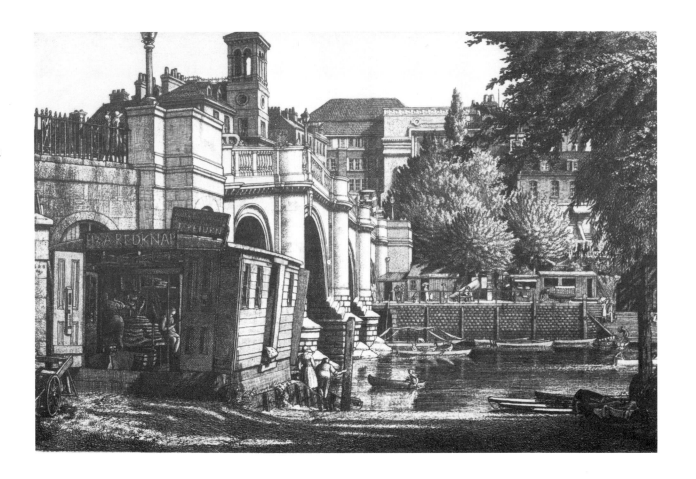

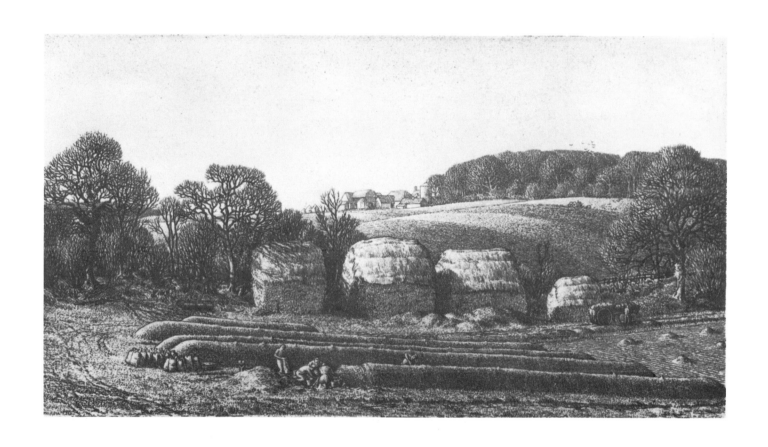

57

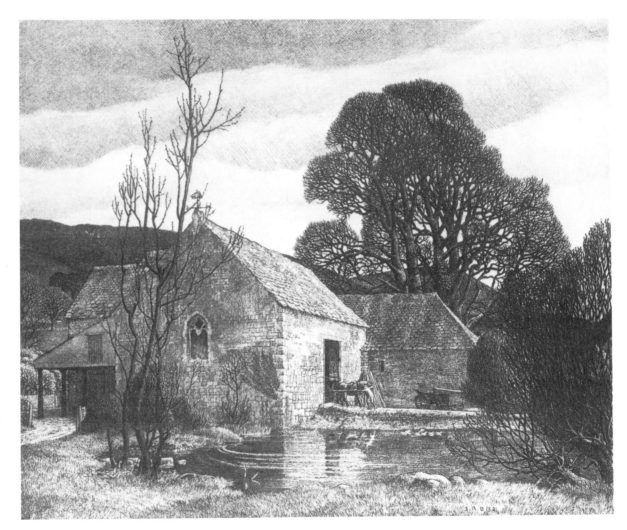

Right
Priory Pond, 1932
(etching, possibly in an edition of 30)

Far right
Mill Street, W., 1932
(etching in an edition of 25)

58

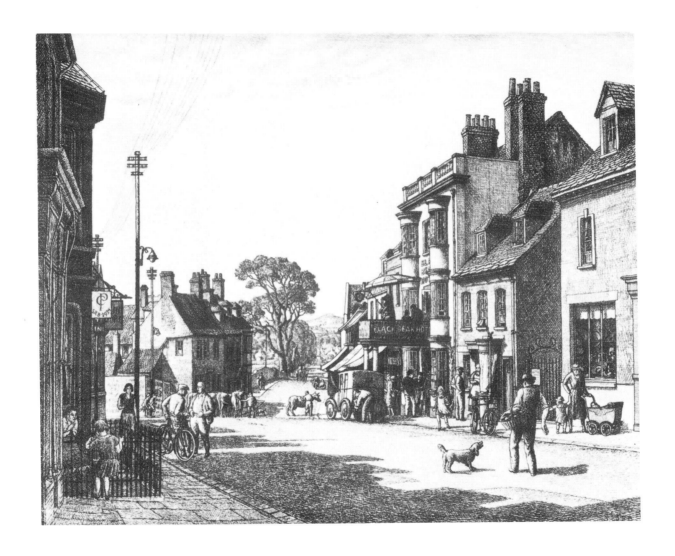

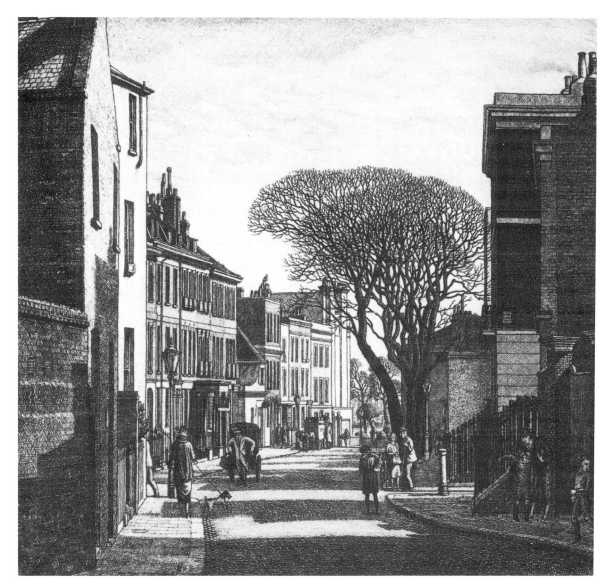

Far left
Wareham, Dorset,
1934 (etching in an
edition of 50)

Left
Cheyne Row, Chelsea,
1935 (etching in an
edition of 50)

61

Catalogue raisonné

No.	Year	Title	Size	Edition	Published	Medium	
1	1928	Hawes Farm	21.9×39.7 cm (8⅝×15⅝ in)	35	Twenty One Gallery	Etching	*View at West Wickham in Kent etched at the Royal College of Art in 1927. Priced at 3½ guineas on publication in 1928*
2	1928	Addington, Kent	16.2×27.3 cm (6⅜×10¾ in)	40	Twenty One Gallery	Etching	*Near West Wickham. Etched at the Royal College of Art in 1927. Priced at 3 guineas on publication in 1928*
3	1928	Elms at West Wickham	14.6×20 cm (5¾×7⅞ in)	40	Twenty One Gallery	Etching	***Layhams Farm*** *added to title inscribed by S.R.B. on etching 26/40. Etched at the Royal College of Art in 1927*
4	1928	Old Oak at West Wickham	10.5×13 cm (4⅛×5 in)	(35)	Twenty One Gallery	Etching	*Listed in* Fine Prints of the Year *for 1928 as an edition of 35, but S.R.B. says, 'under-etched. No edition'*
5	1928	Elm and Cart at Mells, Somerset	15.5×12 cm (6⅛×4¾ in)	35	Twenty One Gallery	Etching	*Called* **Elm at Mells Somerset** *in* Fine Prints of the Year *for 1928, where the edition is listed as 25. Published in 1928 at 2 guineas*
6	1928	The Tip Cart	9.8×13 cm (3⅞×5⅛ in)	35	Twenty One Gallery	Etching	*1st state has a Dutch barn in the background; in 2nd state the barn is eliminated. Etched at the Royal College of Art. Published in 1928*
7	1928	Shops at Shere	13×21 cm (5×8⅜ in)	—	—	Lithograph and Colour	*Lithograph and colour. S.R.B. remembers doing this in 1928 at the Royal College of Art*
8	1928	Shere, Surrey	16.2×20 cm (6⅜×8 in)	10	Twenty One Gallery	Aquatint	*Aquatint. S.R.B. remembers doing this as a lithograph at the Royal College of Art in 1928*
9	1929	Mells, Somerset	14×18 cm (5½×7⅛ in)	40	Twenty One Gallery	Etching	*The third trial of the 2nd state was tried on a vellum paper. Published at 2 guineas according to* Fine Prints of the Year *for 1929*
10	1929	The Field Corner	12×16.2 cm (4¾×6⅜ in)	40	Twenty One Gallery	Etching	*Field with a hayrick based on the 'family' land at Holcombe in the Mendips*
11	1929	Coleford, Somerset	14×20 cm (5½×8 in)	40	Twenty One Gallery	Etching	*A carrying funeral. Edition printed on a vellum paper. Priced at 2½ guineas in the 1930 Twenty One Gallery Exhibition*
12	1929	The Old Ash	14×10 cm (5½×4 in)	40	Twenty One Gallery	Etching	*Old ash near Balcombe. Priced at 2 guineas in the 1930 Twenty One Gallery Exhibition*
13	1929	Tanyard Farm	13×17.5 cm (5×6⅞ in)	40	Twenty One Gallery	Etching	*View near Balcombe, Sussex. Artist's proofs were done in warm black ink on heavy Whatman paper*
14	1929	Suburbia	11×9.2 cm (4⅜×3⅝ in)	25	Twenty One Gallery	Line Engraving	*Line engraving. Inscribed 'Suburbia' in the plate. Signed S.R.B. and dated 29 on the road sign*
15	1929	Lime Kilns, Pole Hill	9.5×12 cm (3¾×4¾ in)	—	—	Line Engraving	*Line engraving. Etched at the Royal College of Art. Not published in an edition*
16	1930	Evening Light near Sevenoaks, Kent	13×16.5 cm (5⅛×6½ in)	40	Twenty One Gallery	Etching	*The artist's proof illustrated on page 53 was done on fine Dutch laid paper in December 1929*
17	1930	New Hop Poles	15.2×13.4 cm (6×5¼ in)	30	Twenty One Gallery	Etching	*View near Riverhead and Pole Hill. Priced at 3 guineas in the 1930 Twenty One Gallery Exhibition*
18	1930	Shepton Mallet, Somerset	14×7.3 cm (5½×2⅞ in)	50	Twenty One Gallery	Etching	*The illustration on page 52 is number 22/50 of the edition. Regarded by S.R.B. as one of his best. Exhibited R.E. 1931 (number 180)*
19	1930	Abbey Barn, Doulting	11.4×14 cm (4½×5½ in)	30	Twenty One Gallery	Etching	*The tithe barn is in Doulting, Somerset. Signed S.R.B. and dated 29 in the plate. Some drypoint in the second and final state*
20	1930	Dulwich Village	13×17.8 cm (5×7 in)	50	Twenty One Gallery	Etching	*Exhibited R.E. 1932 (number 24)*

21	1930	Deserted Barn, Chipstead	15.2×25.5 cm (6×10 in)	—	—	Etching	*Some trial proofs, some chalked, no edition*
22	1931	Swinbrook Bridge	10×15.2 cm (4×6 in)	45	Twenty One Gallery	Etching	*Swinbrook Bridge is near Burford, Oxfordshire; it was replaced during the second world war. Exhibited R.E. 1931 (number 72); R.A. 1932*
23	1931	Fallen Mill Sails	11.4×13 cm (4½×5 in)	35	Twenty One Gallery	Etching	*'Sketched somewhere in Kent, south of Edenbridge'. The impression used for the illustration on page 55 is an artist's proof*
24	1931	Richmond Bridge	11.4×16.5 cm (4½×6½ in)	50	Twenty One Gallery	Etching	*Exhibited R.E. 1932 (number 178). Illustrated in* The Studio, *November 1931, page 348*
25	1931	Burford	14×20 cm (5½×8 in)	45	Twenty One Gallery	Etching	*Exhibited R.E. 1931 (number 28). Illustrated in Kenneth Guichard, British Etchers 1850–1940 (Robin Garton, 1981), plate v*
26	1931	Stroud Canal	12×17.8 cm (4¾×7 in)	—	Merrihill Press, Dyfed	Etching	*Signed S.R.B. and dated 31 in the plate; regarded by S.R.B. as unfinished. Eight run off for the 1st state*
27	1931	Storm over Pole Hill, Kent	10.8×21.6 cm (4¼×8½ in)	15 (20)	Merrihill Press, Dyfed	Hand-coloured Etching	*A few only were printed in black plus two colours; all were added to by hand, but most were to be completely hand-coloured*
28	1931	The Old Hedger	8.9×8.9 cm (3½×3½ in)	—	—	Etching	*Four prints only made*
29	1931	Ide Hill, Kent	12×21 cm (4¾×8¼ in)	—	—	Etching	
30	1931	Beeches in Ashdown Forest	12×21 cm (4¾×8¼ in)	—	—	Etching	
31	1932	Potato Clamps	10×18 cm (4×7⅛ in)	25	Twenty One Gallery	Etching	*Sorting potatoes at Keston, Biggin Hill, Kent. 'You can see the straw ventilation going up, covered with earth, like little chimneys'*
32	1932	Priory Pond	13.4×15.5 cm (5¼×6⅛ in)	(30)	Twenty One Gallery	Etching	*Priory Pond is near Kingstanley, Stroud, Gloucestershire. The 1st edition and records were lost in the war but the plate survived*
	1981	Priory Pond	13.4×15.5 cm (5¼×6⅛ in)	25	Merrihill Press, Dyfed	Etching	
33	1932	Mill Street, W.	14.6×17.1 cm (5¾×6¾ in)	25	Twenty One Gallery	Etching	*The watercolour of this was illustrated in* The Studio, *February 1933, page 98. Exhibited R.E. 1933 (number 107)*
34	1932	Cornish Farm, Trebarwith	11.8×14.6 cm (4⅝×5¾ in)	—	—	Etching	
35	1932	Old Slate Quarry	19×14 cm (7½×5½ in)	—	—	Drypoint	*The only full drypoint. On the cliff at Trebarwith: 'The old slate quarry, but the building in the foreground could be an old lead mine.'*
36	1934	Wareham, Dorset	13.4×15.9 cm (5¼×6¼ in)	50	Print Collectors' Club	Etching	*The final trial of the final state is illustrated on page 60. 'P.C.' has been inserted with slight addition of sepia. Exhibited R.E. 1934*
37	1935	Richmond, Yorks	7.3×18 cm (2⅞×7⅛ in)	50	Fine Art Society	Etching	*Priced at £2 10s on publication. Exhibited R.E. 1935 (number 199)*
38	1935	Cheyne Row, Chelsea	15×15.2 cm (5⅞×6 in)	50	Fine Art Society	Etching	*Priced at £3 10s on publication. Exhibited R.E. 1935 (number 55); R.A. 1935*
39	1935	Darby and Joan Cottage	12.4×16.5 cm (4⅞×6½ in)	No full edition	Fine Art Society	Etching	*Near Bures and Assington, Essex. A hand-coloured edition of 15 has been started. Exhibited R.E. 1938 (number 129)*
40	1936	Oxfordshire Cottage	10.5×15.5 cm (4⅛×6⅛ in)	40	Fine Art Society	Etching	*Near Woodstock. Signed S.R.B. and dated 36 in the plate. Exhibited R.E. 1936 (number 44)*

Storm over Pole Hill, a dramatic watercolour
done when the artist was 23, has achieved its effect
by accuracy of tone and a compelling simple
design – a gentle hill in Kent under English clouds
has become as sublime as an Alpine storm. One of
the artist's most successful etchings was made
from this subject in 1931.

The early sketch book studies of trees (left) in
places like Pole Hill provided important experience
on which Badmin was able to draw in his later
definitive illustrated books on trees.

*Signed: S. R. Badmin, inscribed 'Pole Hill' and dated
Dec. 1929*
16 × 32cm (6¼ × 12½in)

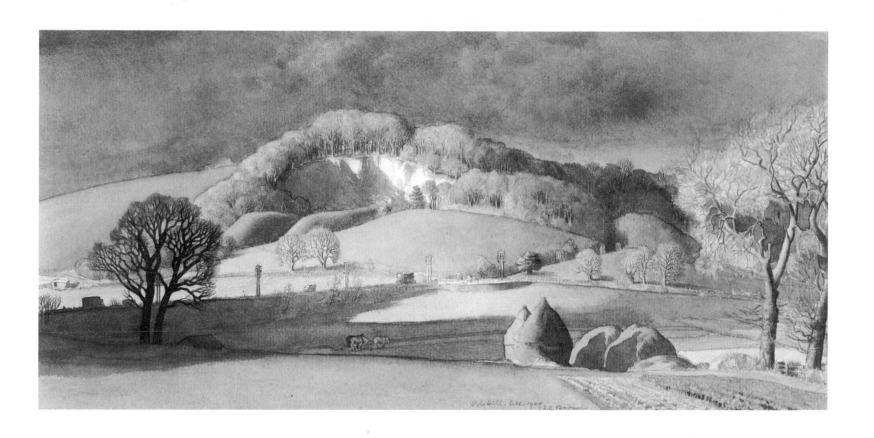

Pole Hill. Dec. 1909 S.A. Bosdin

65

Isleworth Reach was first exhibited in 1934 at the Royal Watercolour Society's 202nd exhibition where it excited great admiration. One critic wrote: 'Mr S. R. Badmin again achieves the impossible, enabling us to see both the wood and the trees, miraculously reconciling minute detail with atmospheric breadth.' This 'reconciliation' is the essence of Badmin's art at its best. Although still only in his twenties, his 'exquisite finish and almost microscopic detail' had already been widely commented on – qualities that can be seen here to perfection in his delicate, precise treatment of the trees, a subject for which he was later to become famous.

The inspiration for 'Isleworth Reach', painted in 1933, came when the artist, then teaching part-time at Richmond Art School, took one of his regular walks along the Thames with his students 'to look out a nice view' for them to draw. He made his usual quick pencil sketch to define the masses and their shape for future composition, and then went back to visit the site several times, making colour notes to indicate the overall tonal values, painting in just one or two areas with an exact colour as a detailed reminder (left).

Exhibited 1934 R.W.S. Summer Exhibition
Signed: S. R. Badmin and dated 1933
23.5 × 30.5cm (9¼ × 12in)
Reproduced by courtesy of the Walker Art Gallery, Liverpool

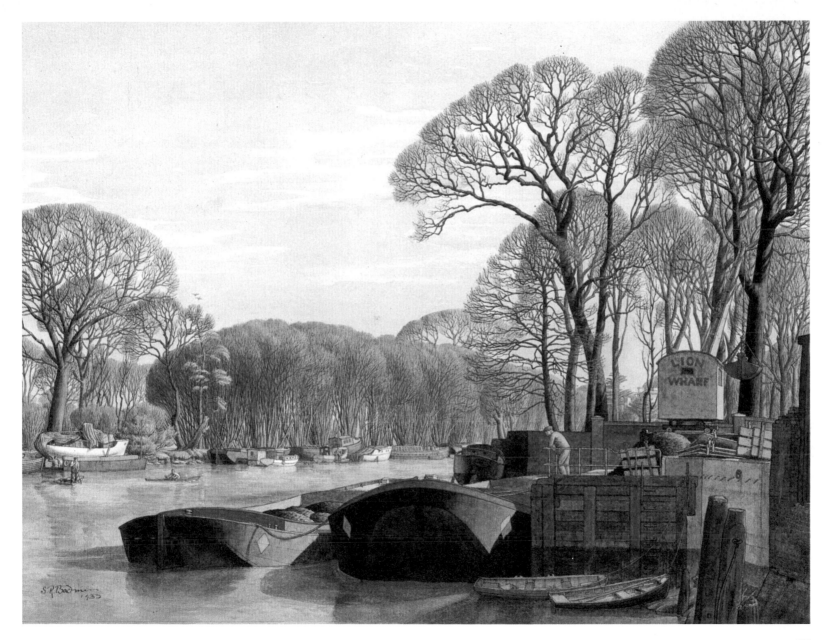

Spring, Upper Slaughter is another favourite from Odhams' *British Countryside in Colour*, painted in 1949. Badmin describes his travelling on this occasion as 'that marvellous commission when I was asked by Odhams to travel to the most characteristic areas of the British Isles. It was their contribution to the South Bank Exhibition and for this I remember getting special petrol coupons.' Badmin has always liked to take his time in a new place before deciding exactly where to sit and paint the view. 'The village is very nice indeed, but it looks so much better from this end than when you first come into it from the main road.'

Published 1951 Odhams British Countryside in Colour
Signed: S. R. Badmin
26.5 × 35.5cm (10½ × 14in)

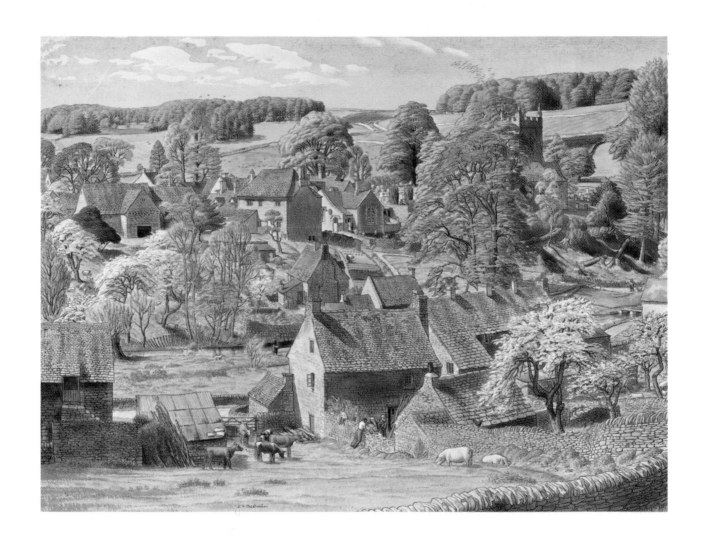

Spring comes to a Cotswold village. Unusually for Badmin, this village is not real but imaginary, containing all the prettiest features of all the villages in the Cotswolds, one of his favourite areas of the country. It was done in the 1940s after many tours, and Cotswold buffs will recognise features from many different towns and villages. The mill in the foreground, for example, is from Naunton, not far from Upper Slaughter in Gloucestershire.

Published 1950 Odhams Nature through the Seasons; *1970 Royle's* Artists' Britain *Calendar as 'May morning in the Cotswolds'*
Signed: S. R. Badmin

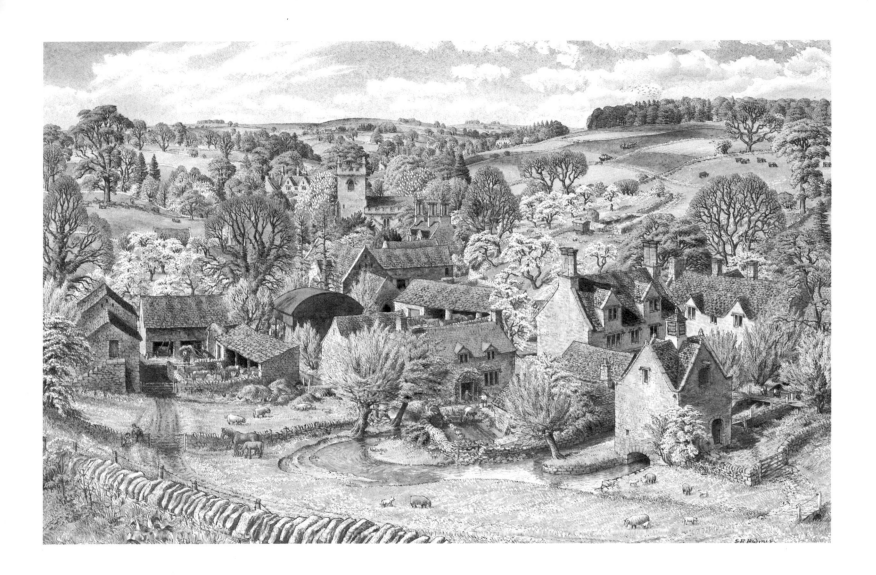

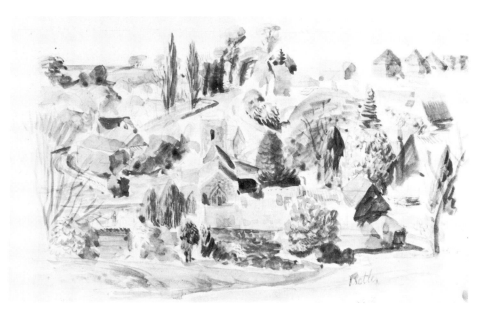

Springtime at Ratley, near Edgehill was chosen from the artist's own collection to be included in the prestigious British Watercolours and Drawings exhibition sent by the British Council to Peking in 1982. The exhibition was a great success, with seven thousand people a day clustering around the best of British art, from Thomas Rowlandson to Sir John Piper. This first-ever major exhibition of British art in the People's Republic of China, said to be an important contribution to Anglo-Chinese relations, later received further critical acclaim on its display during the Edinburgh Festival.

Andrea Rose, organiser of the exhibition, wrote in the catalogue of this painting: 'details such as the blossoming of the horse chestnut trees, the newborn lambs in the field, the variety of leaf, and the pale green light characteristic of early spring in England, all show Badmin's accurate observations of the specific season in the English rural calendar.'

Published 1951 Odhams British Countryside in Colour; *exhibited 1951 R.W.S. Autumn Exhibition and 1982 British Council*
Signed: S. R. Badmin

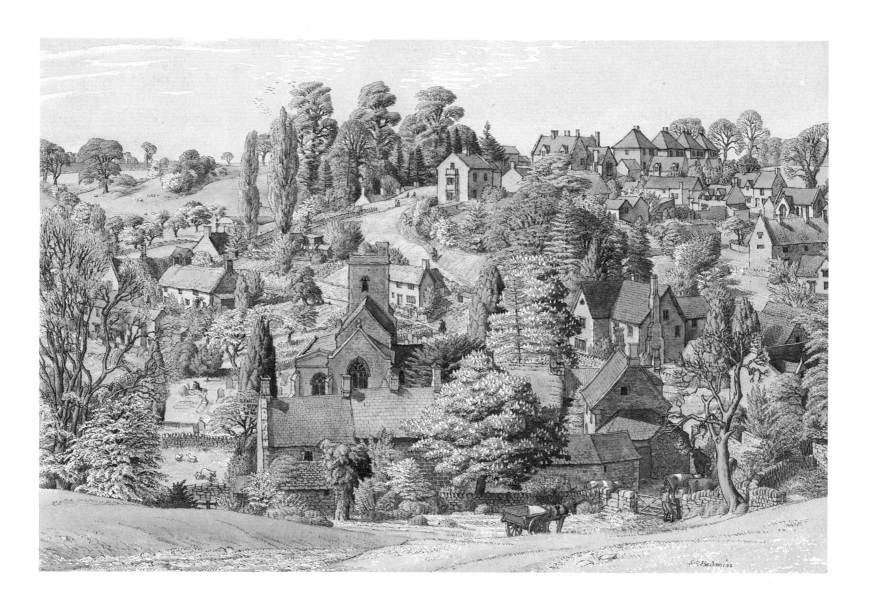

Old-fashioned harvest near Luscombe, Devon
records a method of storing grain that was dying
out rapidly after the second world war. The grain
was cut, left to dry, then stooked in the fields to be
collected (seen in the background on the right).
The ricks were then built with a stook of sheaves in
the middle to create a funnel, held in place by
tightly packed layers of sheaves all round. The
pattern was then repeated in layers two or three
times. The funnel in the middle aerated the rick,
preventing it from spontaneously catching fire.
The finished rick on the right is being thatched for
protection during the winter.

This was one of the paintings Badmin was
commissioned to do by Odhams Press. He
recorded the detail of the rick builders in his
sketch book (left), and expanded the composition
in a preliminary watercolour wash (above).

Published 1950 Odhams, Nature through the
Seasons
Signed: S. R. Badmin
22 × 35.5cm (9 × 14in)

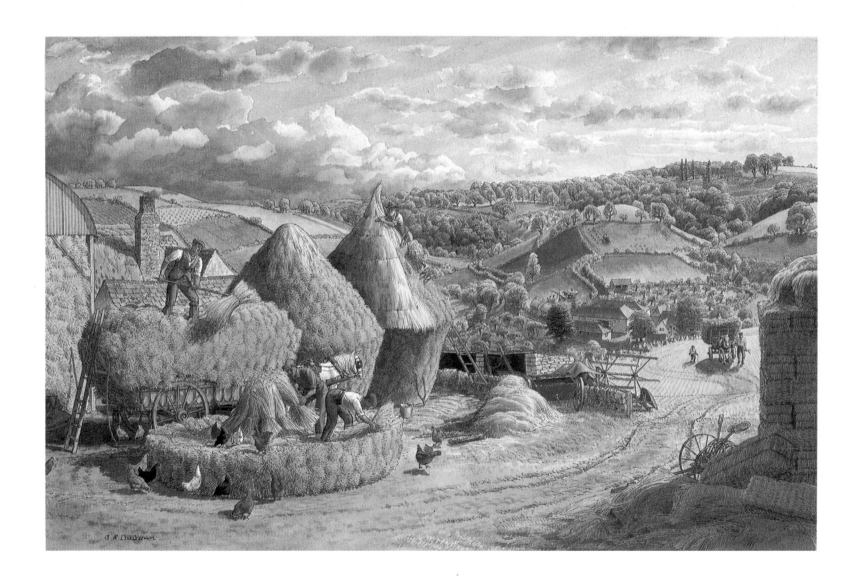

75

A corner of the greenhouse. Most of this remarkable watercolour was done on the spot in Badmin's own garden at the house in Forest Hill, South London, where the family lived in the 1950s before they made their final move to the Sussex countryside. His daughter Galea can be seen with the watering can. His wife Rosaline remembers it all with pleasure, but disowns the rather stylish hat: 'It was the one and only red dress I had, but whatever was I doing with a hat like that in the garden?' From this and other earlier watercolours, it is apparent that Badmin could easily have earned his living just as a still-life watercolourist. The extent of his careful study and observation may be seen in the watercolour study of the June-flowering *Epiphyllum*, done in 1953 (left).

Signed: S. R. Badmin
35.5 × 28cm (14 × 11in)

77

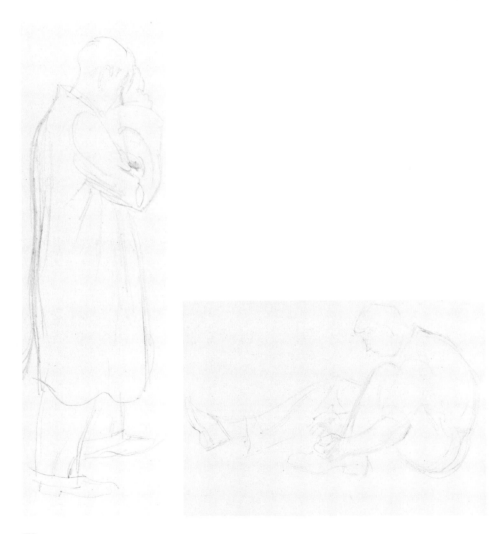

Skating in St James's Park, an amusing piece of Breughelesque fun in front of Buckingham Palace, was done in February 1954 in a long spell of freezing weather. Badmin remembers that it was very cold work for an artist, as he came several days running to sit and sketch. 'It was fun to see civil servants from Whitehall in their pin-striped suits walk up to the lake with their briefcases, open them up and take out a pair of skates.' Badmin's children have always been willing volunteers to model in his pictures: in the foreground groups there are various combinations of Joanna, Patrick and Elizabeth. The pencil portraits (left) of Patrick putting on his skates, and of the bystander taking a photograph, are taken from one of the artist's sketch books.

Adrian Bury in an article on Badmin published in 1957 noted that in this picture the artist took 'the chance to prove his gift for arranging groups of moving figures. Casual as they appear, all have been considered in relation to the design as a whole, and their coloured costumes make effective and appropriate notes in the cold snow, ice and leafless trees.'

Exhibited 1984 R.W.S. Autumn Exhibition
Signed: S. R. Badmin, inscribed with the title and dated
Feb. 1954
25.5 × 35.5cm (10 × 14in)

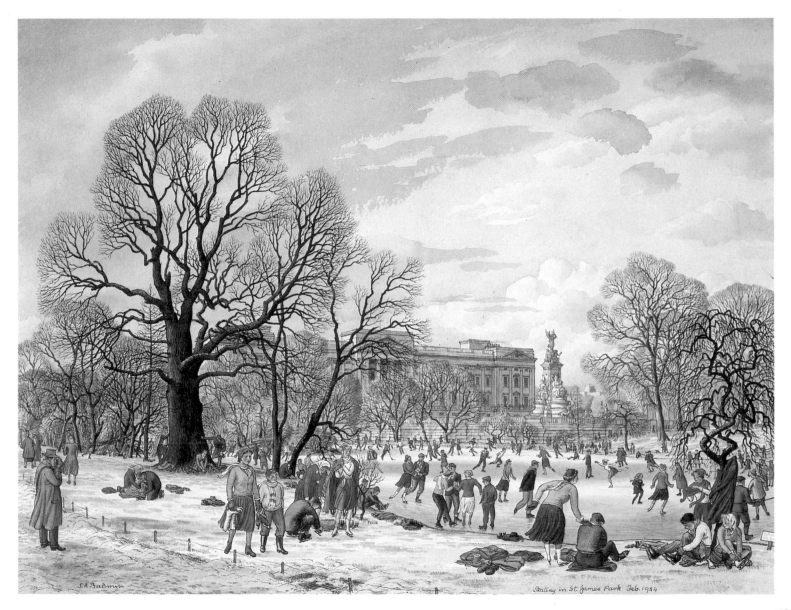

S.R.Badmin

Skating in St. James Park. Feb. 1954

Clearing snow, Pole Hill. On seeing this watercolour again after many decades, the artist didn't at first recall the circumstances in which he had painted it. But a few seconds later memory came flooding back: 'I was interested in this grass growing through the snow, and the shapes it made. It was a favourite spot of mine on the Downs in Kent, and I came here often down the main road from Bromley. Now, look at those rooks – and I suppose that must be a hare. I think this is a very pleasant one.' Indeed, the mixture of care and spontaneity in many of the washes, particularly the distant subtle tones in the beech forest on the hill, make this a very pleasing watercolour.

Badmin's sketch books show many studies of this favourite hill, with many different types of tree apart from beech – from yew to whitebeam (left).

Signed: S. R. Badmin and inscribed with the title
16.5 × 24cm (6½ × 9½in)

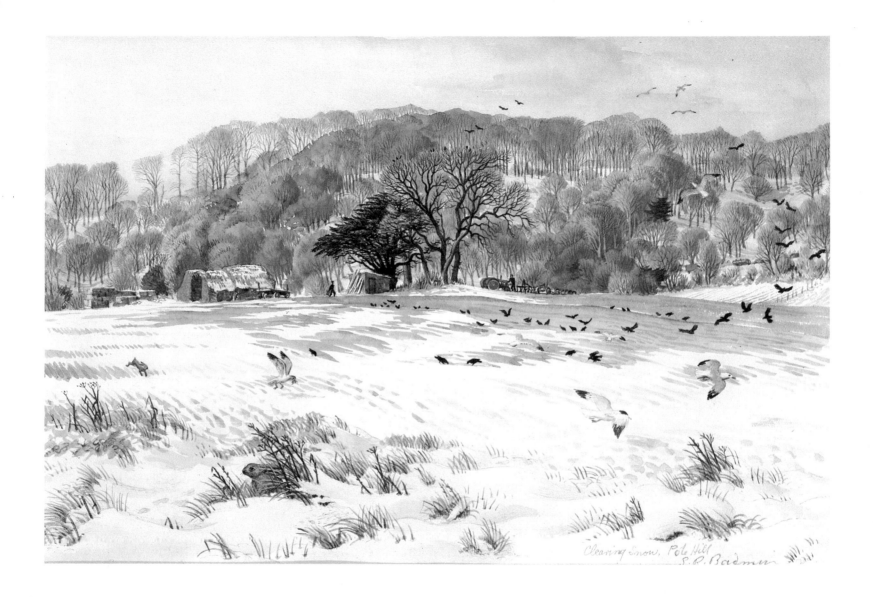

Clearing Snow, Pole Hill
S. R. Badmin

Christmas week, Trafalgar Square was a Christmas card design that now has a pleasingly dated look. To pack so much warmth, light and observation into this small cosy scene is a feat of design sense. The preliminary colour sketch (left) reveals the ability of the artist at an intermediate stage.

Signed: S. R. Badmin, inscribed with the title and dated December '59
35.5 × 20cm (14 × 8in)

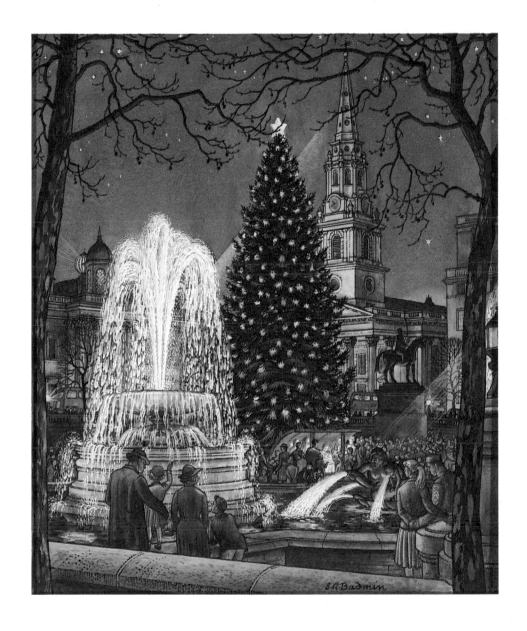

Skating on Oakwood Pond is a spirited composition, based on West Wycombe Common, Kent. From his childhood, Badmin remembered the trees beyond the pond as 'magnificent oaks' but, during the national coal strike of 1926, many of the trees were chopped down or their branches lopped by the local people to provide alternative fuel. Once more, Badmin's family have provided the models for the figures: his son Patrick is skating in the foreground, wearing a bright red jersey.

Exhibited 1960 R.W.S. Spring Exhibition
Signed: S. R. Badmin
26.5 × 19cm (10½ × 7½in)

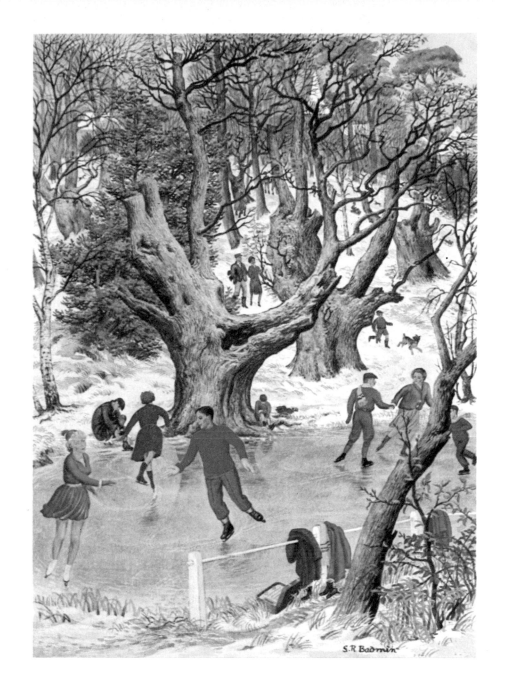

S.R Badmin

Calling in the hounds at the Mile Oak took place just a short walk from the artist's home near Bignor, West Sussex, as can be seen from the signpost – Bignor Hill in the distance with its seasonal variations in colour is the backdrop for his large studio window. Here it is suggested, happily, that the fox at least has no need of signposts and that the hunt will have to return and look picturesque another day. Badmin's own feelings about fox hunting are ambivalent: 'I come down in favour of the anti-fox hunting lobby, but I must say the hunt does look attractive riding across the countryside in their scarlet uniforms.' Mrs Badmin has felt less endeared to the local hunt since a day when the entire pack of hounds hurtled right through their garden, trampling all the flowers and shrubs.

Exhibited 1964 Worthing Art Gallery
Signed: S. R. Badmin

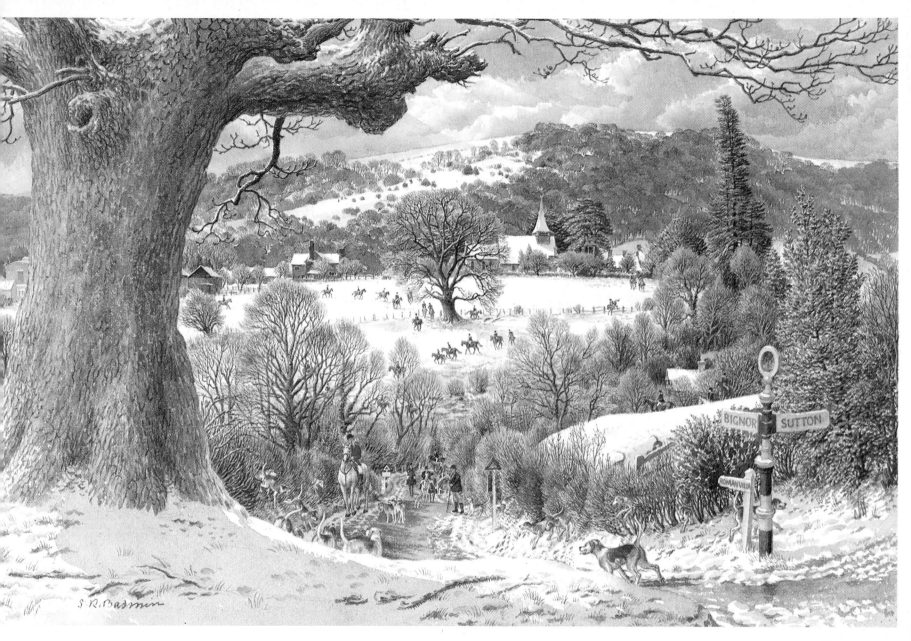

Bolton Abbey, autumn. This most picturesque setting of Bolton Church and the ruined abbey, on the banks of the River Wharfe above Ilkley in the Yorkshire Dales, has been painted by almost every great British artist in the last two centuries. Once more, however, Badmin has found an unusual and compelling viewpoint, and has played on his strengths by an exquisite rendering of each tree with its distinctive foliage and hue. He has then made it come alive with the human figures of the shepherd with his sheepdog and the family of tourists strolling down the path, marvelling at the remains of an age in which Augustinian canons sought and found the perfect setting for their labours seven centuries ago.

Exhibited 1967 R.W.S. Autumn Exhibition; published 1969 Royle's Artists' Britain Calendar (September). Signed: S. R. Badmin

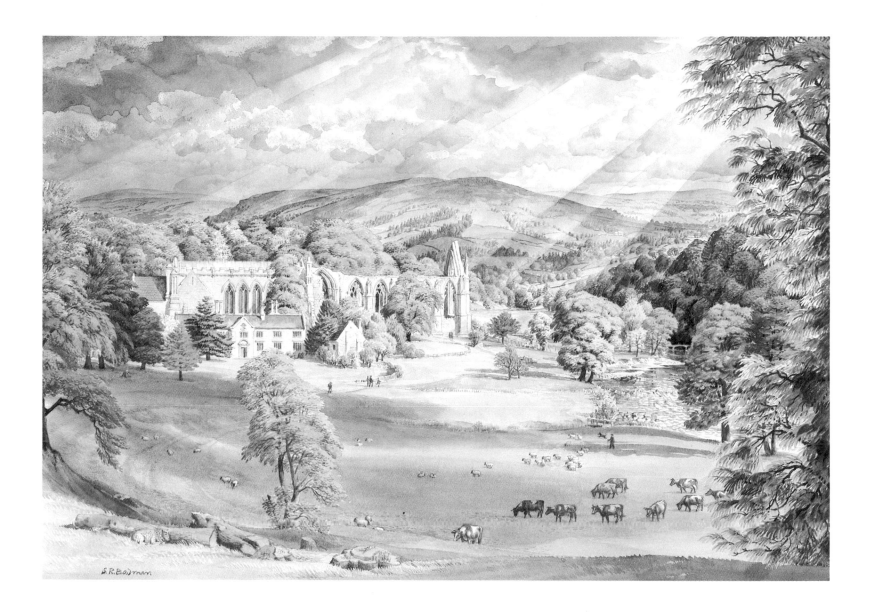

Fallen clapper stones, Dartmoor. A clapper
bridge is a primitive type of bridge, in which slabs
of stone (or sometimes planks of wood) lie on top
of piers made simply of piled-up smaller stones.
Badmin came across this ancient one well away
from the usual tourist run. 'There's a famous
bridge near Dartmoor, at Postbridge,' he recalls,
'but there's a much more interesting one just
around the corner.' The arch of the newer bridge
that carries the road can just be seen in this
picture. Man has moved on and nature has
reasserted itself, enveloping the massive rocks in
shades of green – slimy moss, lichen, fern and
larch.

Exhibited 1968 R.W.S. Autumn Exhibition
Signed: S. R. Badmin and inscribed with the title;
inscribed and dated under the mount, 'Clapper Bridge
near Princeton Dartmoor. August 1968'
20.5 × 28cm (8 × 11in)

"Fallen Clapper Stone, Dartmoor"

91

Master Fox decides to go home, 'having given the Leconfield Hunt a fine run right through the village of Byeworth'. This shows the artist at his most narrative and humorous. While the hunt struggles in all directions across the Sussex countryside, now bathed in the luminous light of a late snowy winter's afternoon, Mr Fox cocks his snook and is off home for an early tea. From the partly layered hedge in the foreground to the distant elms, this is Badmin at his best and most naturalistic. One's eye is drawn in stages from the foxy triumph in the foreground to the hunting turmoil amidst the farm buildings in the middle distance and beyond to the trees and fields lying in the soft, low shadows and to Petworth Church under a flurry of snow. The popularity of this painting as a greetings card shows, I am sure, the real and popular appeal of hunting – where the fox always wins.

Many of the animals in Badmin's pictures are based on direct studies from nature. While out walking on the Downs one day, he found the corpse of an old fox (one that had died of *natural* causes) and made several sketches of it (left).

Exhibited 1969 R.W.S. Autumn Exhibition
Signed: S. R. Badmin
19.5 × 29cm (7¾ × 11½in)

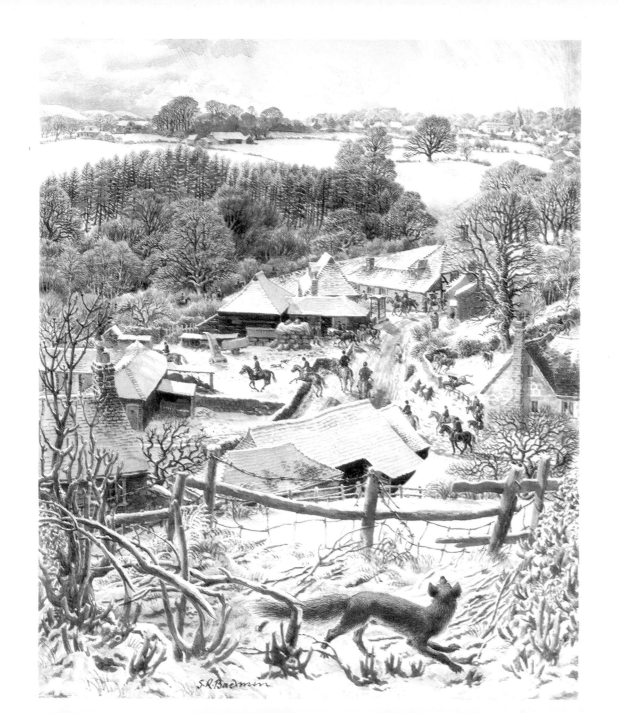

S.R.Badmin

93

Clovelly has the evocative air of happy remembrances of holidays in the summer sun. Adrian Bury succinctly described this ability of Badmin 'to organise so much pictorial information, to preserve unity of effect and retain a vision neither photographic nor impressionistic' as 'a commendable stylistic performance'.

The sketch (left) shows how Badmin set about coping with the difficult shape of the projecting mass of Clovelly pier.

Exhibited 1970 R.W.S. Spring Exhibition
Signed: S. R. Badmin
23.5 × 38cm (9¼ × 15in)

Hazlett Wood Farm, Knockholt, Kent was done as a commissioned work for Howard Rotovators Ltd and was painted during a special demonstration at Hazlett Wood Farm between 1971 and 1973. After the maize was harvested by the machine on the right, the rotovator on the left of the picture went over the ground. Badmin, who has always been fascinated by farm machinery, thought it a very effective device, since it needed to go over the ground only once, making the usual elaborate tilthing process unnecessary. 'I was so impressed', he said, 'that I put my fee into shares in the company. It went downhill after that!'

Signed: S. R. Badmin

Evening snow. If Badmin, in his long career, had never travelled more than ten miles from his home in Sussex, he would still have found enough changing moods of nature to record. Here he has caught perfectly the chill beauty of a winter sunset. The pervading atmosphere is intensified by the depiction of solitary activities – a hare races across the crisp, snowy furrows; a lonely rider walks his horse home from exercise, and a small bonfire at the edge of the field suggests the continuing industry of a farm even in winter. This very sunset may still be seen today, from the left of the road from Petworth to Midhurst, just west of the village of Tillington.

Exhibited 1971 R.W.S. Spring Exhibition; published 1974 Royle's Artists' Britain *Calendar (December) Signed: S. R. Badmin*

Receding floods, Pulborough. The banks of the River Arun have always tended to flood in this part of Sussex, and Badmin often thought of how he might depict it in a painting. As a protection against flooding, the river has been banked above Pulborough, but exceptionally heavy rain still causes the water to go over the top and produce enormous lakes in the fields. On this occasion, the flood waters went higher than the level of the bar in The Swan public house, the long low building on the left of the picture.

Much of this watercolour was done on the spot, giving it a great feeling of immersion in the wet atmosphere. The scudding sky and the plashy foreground are of soft, skilfully laid washes with no preparatory pencil work. Much of the general tone of the elms surrounding the church was done outdoors, with the finer details finished in the studio. This is a mature work by a master of watercolour.

Exhibited 1974 R.W.S. Spring Exhibition
Signed: S. R. Badmin, inscribed with the title and dated 1974
19 × 28cm (7½ × 11in)

100

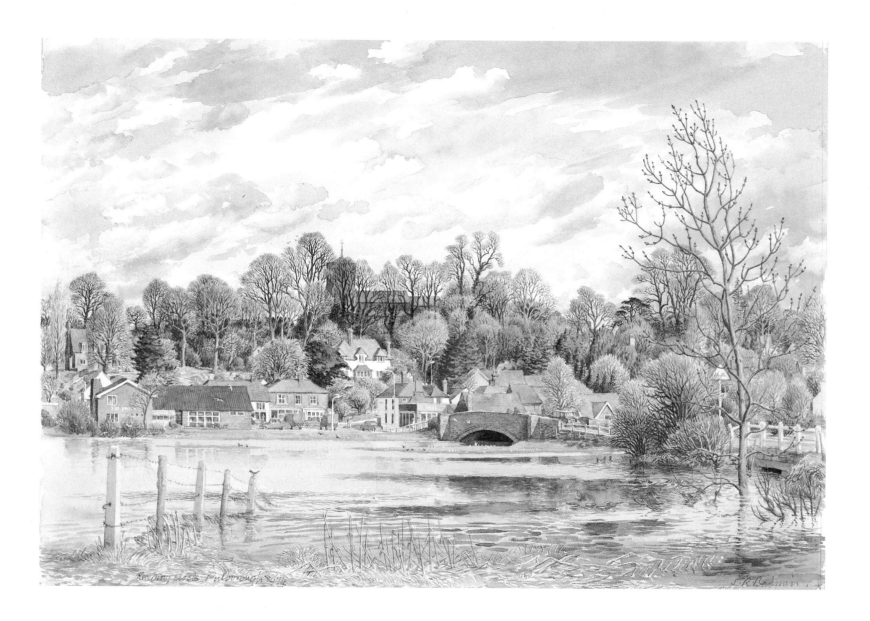

Kealing Woods, Pulborough Sussex

J. R. Badman

101

Ruined barn near Billingshurst station. 'I used to see the barn from the train home to Pulborough, so I decided to find out where it was. I don't think it is standing any longer.' This simple and perfectly designed picture has a sad feeling about it. The old dead elms must also be down by now, and only the ubiquitous elderflower is likely to remain.

Inscribed with the title and dated 1974

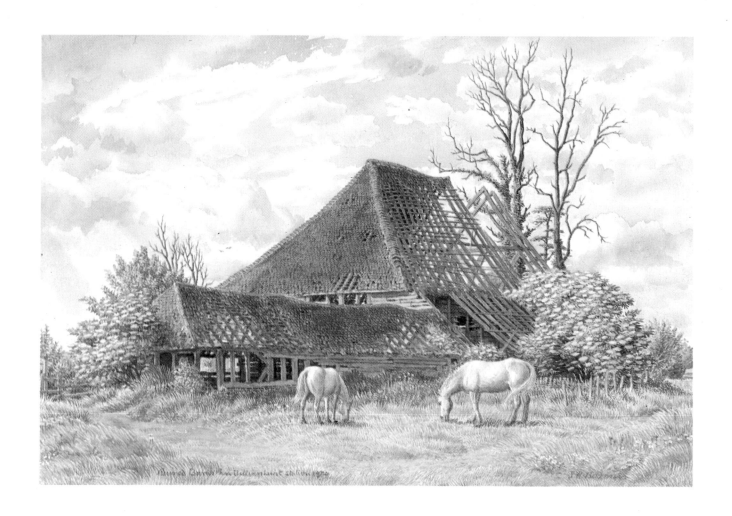

Ruined Barn near Billingshurst station 1944 F.R. Beldram

103

Farmhouse in Forth Valley was a chance finding in 1956 when Badmin was on a commissioned sketching tour. 'We went up the valley, trying to get a different view of Stirling Castle, and the farm was at the end of the road in whitewashed stone and around here there were about six little haystacks.' The artist still finds this a lovely view and certainly it has all the ingredients of a Badmin work – a haystack built to a traditional design, trussed up and held down with weights; a variety of farm machinery; several sturdy workhorses and, not least, a fine Spanish chestnut by the gate. Despite all these distractions, a view of Stirling Castle is included, albeit in the far distance on the extreme right of the picture. The watercolour was finally completed in 1974, but never exhibited.

The pencil drawing (left) of a workhorse in full harness, labelled 'The Cart', is from the artist's sketch book.

Signed: S. R. Badmin, inscribed with the title and dated 1956–74
12.5 × 21.5cm (5 × 8½in)

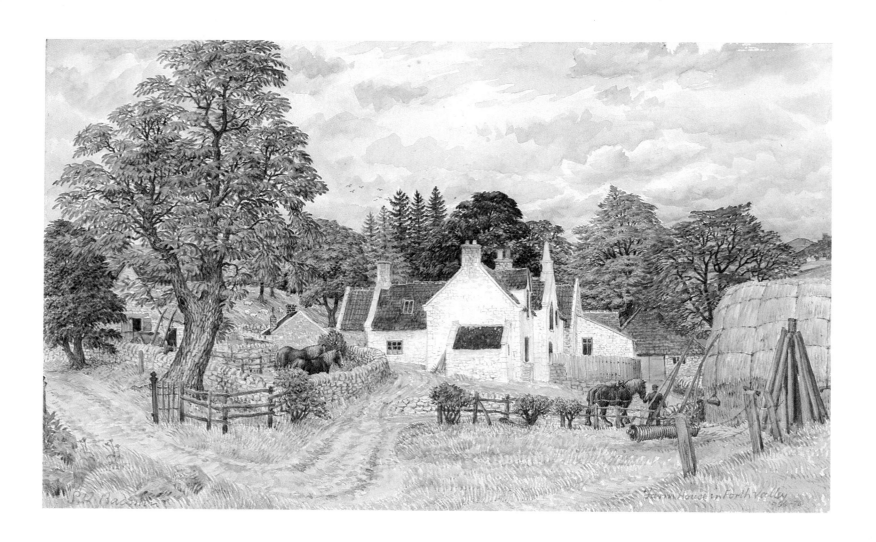

Farm House in Forth Valley

105

Autumn wedding at Findon. When the artist first sat down on the grass verge in front of the church to start this watercolour the area was empty, but soon cars and people started to arrive. As he says, 'I had to retire in the end, because I got mixed up with the wedding.' Badmin has always had an eye for putting human activity into his pictures. He took the opportunity in this case, and seems pleased with the result. 'People going in and out does enliven it a bit. Royle's decided to publish this as a wedding card and it became a best-seller. There is an interesting walk starting off there; it goes up and round the back where you can look down on the church.' This is part of the walk to Cissbury Ring, a prehistoric hill fort on the Downs above the village of Findon, in West Sussex.

Exhibited 1976 R.W.S. Spring Exhibition
Signed: S. R. Badmin and dated 1975

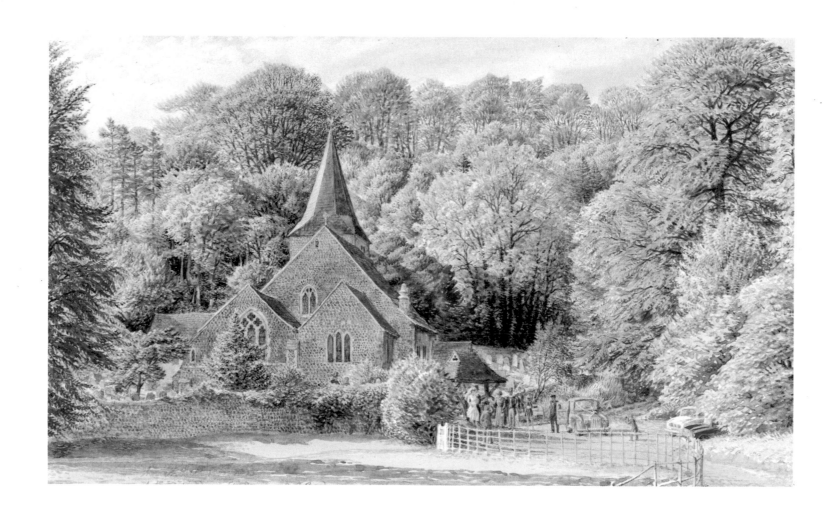

Late snow. Whenever possible, Badmin likes to paint snow scenes directly from nature, so the collector who commissioned a snow scene from him had to wait several years for this one, until an unusually late snowfall in the spring of 1975. The view is of the Badmins' back garden in West Sussex, always a bird haven. Galea, their daughter, is in the garden feeding her pony which had injured its back leg and had to be put in a new, enlarged, stable shed. The artist remembers building this shed in twelve hours for the injured animal; now it is largely hidden by a white winter vibernum. The conifer on the right now stands 12 metres (40 feet) high – even though it was bought as a 'dwarf' one! – and there is Mrs Badmin's honey still for tea.

Exhibited 1975 R.W.S. Autumn Exhibition
Signed: S. R. Badmin, inscribed with the title and dated
Ap. 1975
13 × 21.5cm (5 × 8½in)

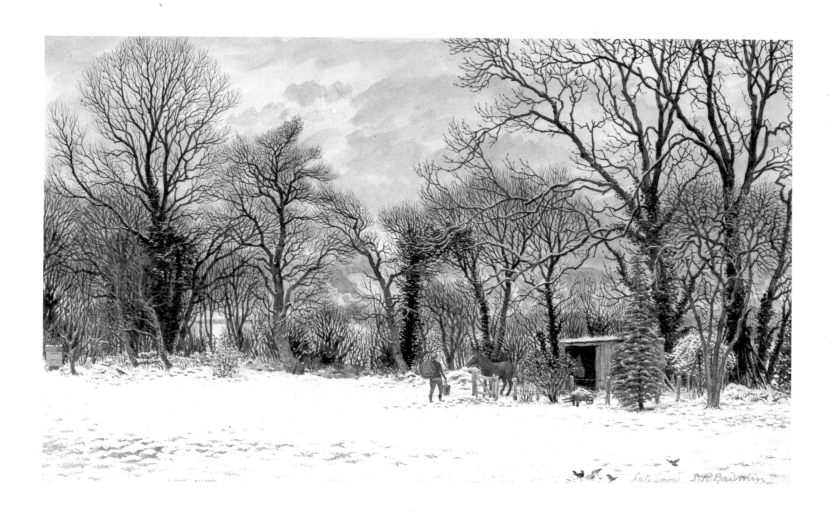

Late Snow S.R.Badmin

109

Spring Head Farm, April. The farm is near Storrington in West Sussex: of all the greetings cards that Royle's Publications have made of S. R. Badmin originals, this has been the best seller. The idyllic setting for the house is in Parham Park, and the combination of its small scale and perfect situation makes the picture seem almost like a private fantasy that the life depicted in it might, in fact, be attainable. The little figures sitting out in the sun reading, with the house dog at their side, accentuate an irresistible air of domesticity.

Exhibited 1975 R.W.S. Autumn Exhibition
Signed: S. R. Badmin and inscribed with the title

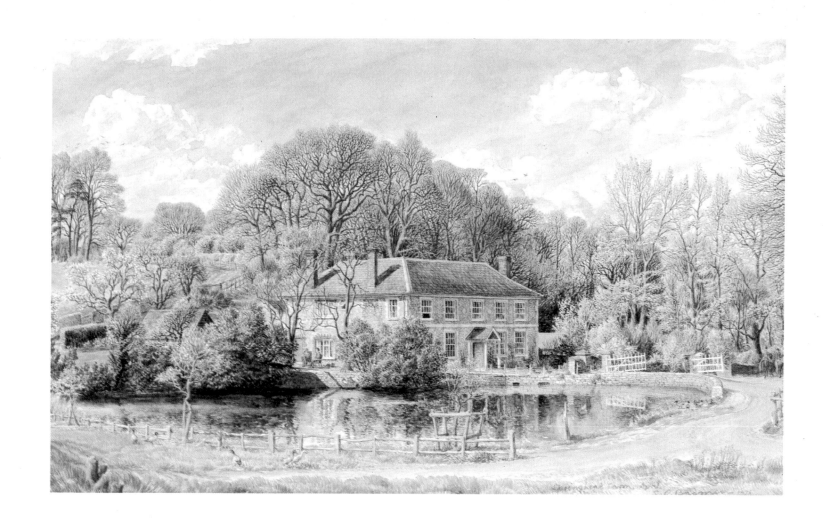

111

Loading timber in a West Country wood was based on Bury Hill, West Sussex. The beech wood on the hill became diseased and had to be felled. Badmin took the green lorry with the resourceful back-lift from a sketch he had made while touring in Castle Combe, Wiltshire. A typical Badmin touch is the robin in the bottom right-hand corner, surveying the gradual destruction of his territory.

Exhibited 1976 R.W.S. Spring Exhibition
Signed: S. R. Badmin
25.5 × 35.5cm (10 × 14in)

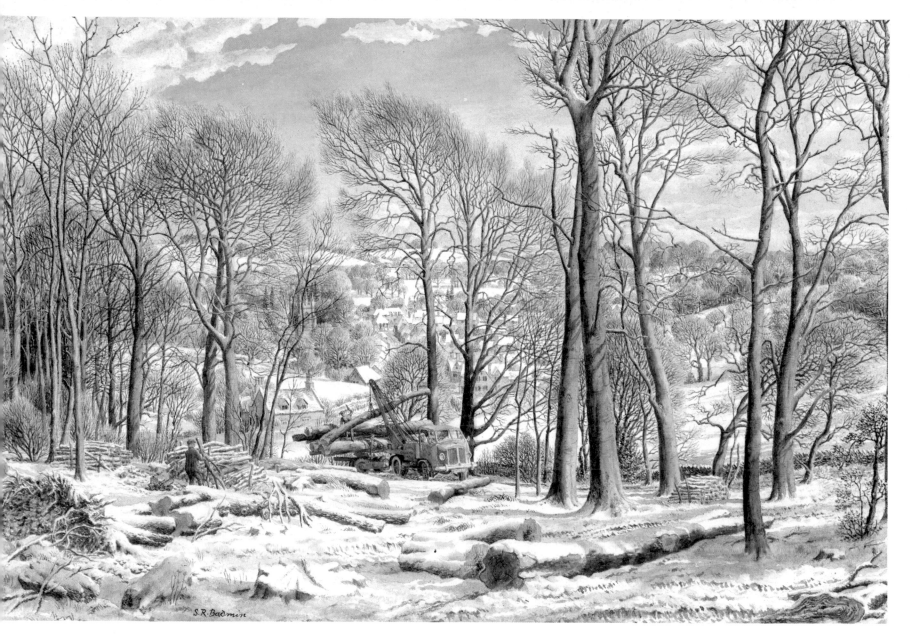

S.R.Badmin

Snowy morning, Mam Tor, Derbyshire is a crisp and inviting scene, indicating the resources that an artist can call on in a long and active working life. Done as a commission for a *Reader's Digest* cover, its inspiration came from the same view that Badmin painted in the late 1950s (see page 117), but the winter atmosphere and the nuances of light and shade were drawn from a much more recent snowfall in the artist's home county of Sussex. The roads over this part of Derbyshire can be completely blocked in winter by ice and snow, and the human activities shown in this picture are typical of Badmin: a sledge is being dragged up the slope on the left while a flock of sheep look on; in the middle distance a snow plough is clearing the road to the farm cottages and workmen with shovels tidy up in its path.

Exhibited 1976 R.W.S. Autumn Exhibition
Signed: S. R. Badmin and inscribed with the title
30.5 × 26.5cm (12 × 10½in)

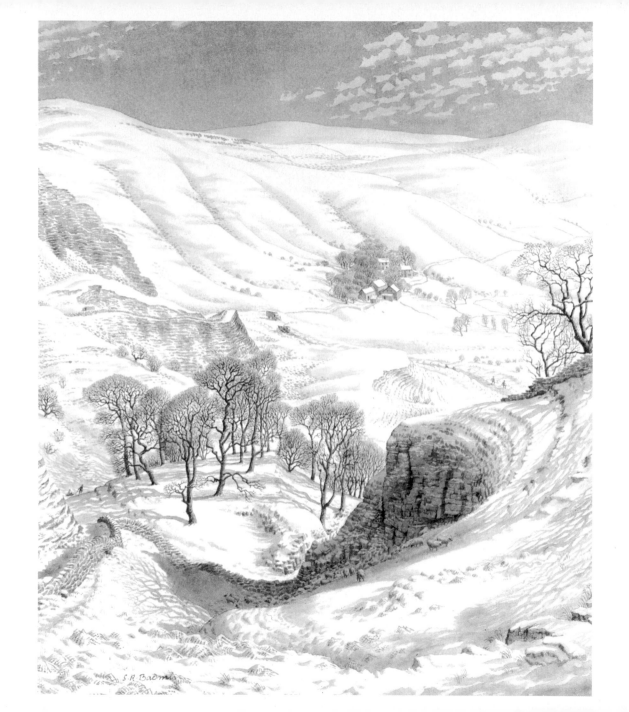

S R Badmin

115

Study for Mam Tor, Castleton

Mam Tor, near Castleton, Derbyshire. In
this, the artist has worked on a slightly larger scale
than usual, which suits the breadth and depth of
the composition. It has remained in his own
collection ever since it was done in the late 1950s
when he was preparing for a series of paintings of
hills. The pencil sketch (left) shows how the artist
defined the masses to help him with the
composition.

Exhibited 1976 Society of Sussex Painters
Signed: S. R. Badmin and inscribed with the title
37 × 45.5cm (14½ × 18in)

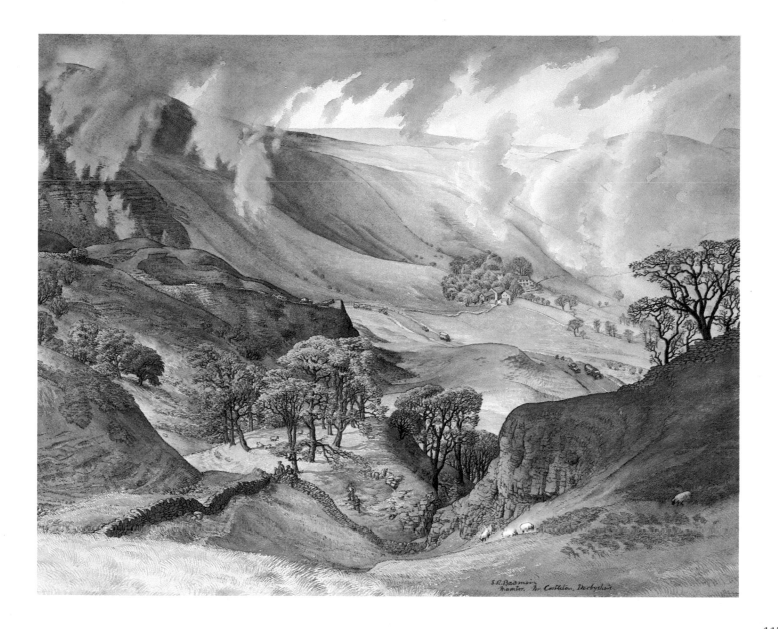

S.R.Badmin
hamlet, nr. Castleton, Derbyshire

117

Harvesting late into the evening shows a West
Sussex view, from Amberley Mount looking
towards Bury, which repays careful study. The
village of Amberley will be away to the right and
the church tower at Bury can be seen in the middle
distance, beyond and to the right of the burning
stubble. In the foreground two chummy hikers are
walking the South Downs Way and are about to
encounter a slope on the bridleway so steep that
horses have to avoid it and take a longer way
round. The River Arun meanders away to the left.
The people on the sailing boat will be taking a
more leisurely look around them than the
passengers on the train speeding by. Badmin
remembers well the problems of an artist at this
time of day: 'I went back several times to get the
tone values of the trees and fields and one evening
I remember the dew coming down so fast that as
soon as I put on a wash it dispersed and spread, as
though I was using blotting paper. It is at times
like these that I sometimes use pastel or crayon for
my colour notes.'

Exhibited 1976 R.W.S. Autumn Exhibition
Signed: S. R. Badmin

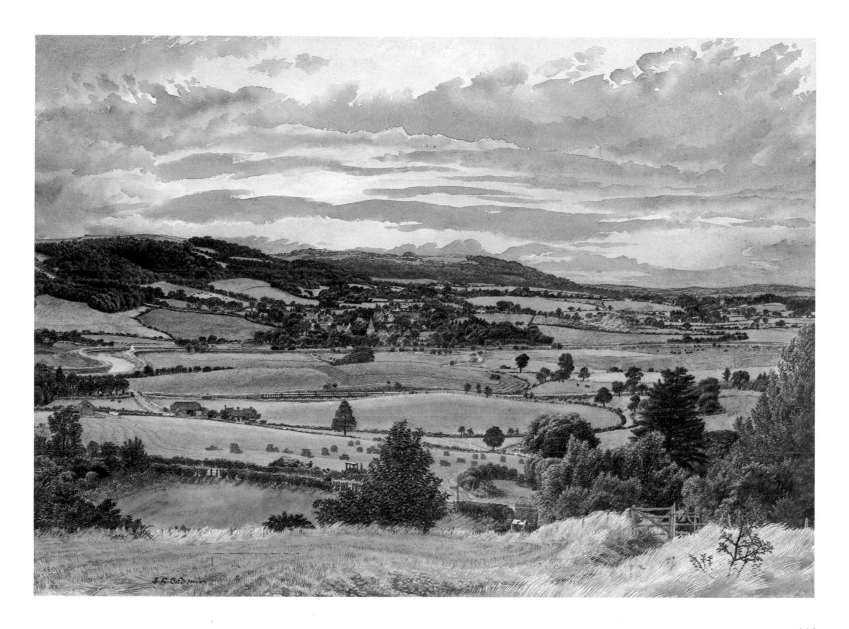

Little Barrington shows the Heythrop hunt on a winter's afternoon, 'discussing the deteriorating weather.' The long shadows on the crisp, bright snow are interestingly balanced by the lowering sky away to the right. The day's hunt is probably over – a great disappointment to the fox, who does so enjoy a romp in the fresh air of midwinter. The disappointed hunters will soon disperse and leave the quiet Cotswold village empty and still – although the tale is told of one frustrated sportsman who came back later and emptied two barrels of a shotgun into the topiary pheasant.

A pencil sketch of the foreground elm (left) has interesting colour notes – 'light pinky' for the bare area half-way up, and 'rich red brown' for the encircling bark.

Exhibited 1979 R.W.S. Spring Exhibition
Signed: S. R. Badmin, inscribed with the title and dated
1979; pencil sketch dated 1977
26.5 × 43cm (10½ × 17in)

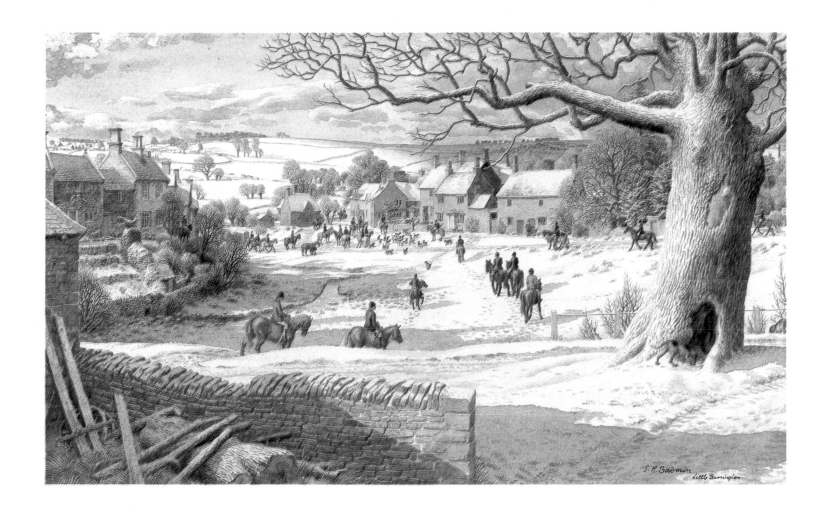

S. R. Badmin

Little Barrington

The Canal at Islington shows a view along the towpath of the Regents Canal, which was discovered by the artist when he was walking back from Royle's, the fine art publishers, to the underground station at the Angel, Islington. The building in the distance beyond the bridge houses Royle's offices and factory. The painting was completed in 1977 and the scene is still unchanged, although no doubt the barges have by now moved on. You can find this stretch of the towpath by a small entrance off Danbury Street just before it crosses the canal. The brightly coloured barges are typical traditional craft, and were observed in minute detail by the artist in his sketch book (left). Another Badmin touch is the dog in the flower bed on the right, enjoying a spring daffodil.

Exhibited 1978 R.W.S. Spring Exhibition
Signed, dated and inscribed: S. R. Badmin '77 Islington Canal

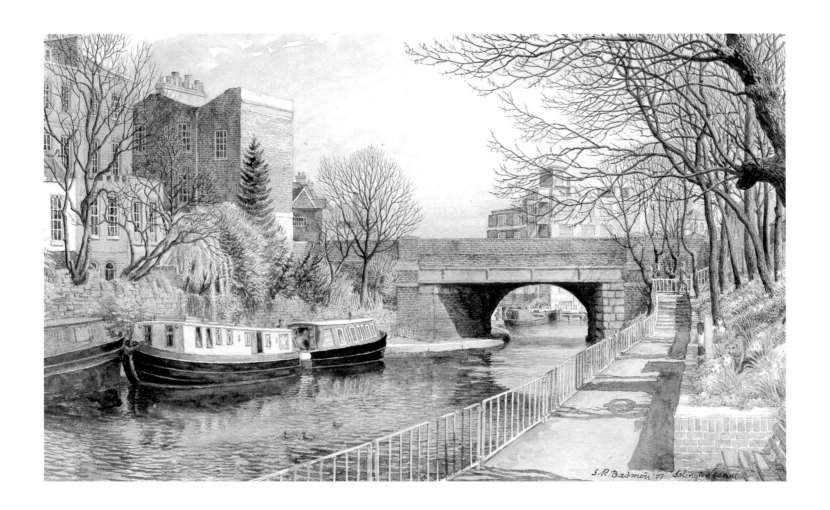

S.R.Badmin '77 Islington Canal

123

Frosty evening, Patching Pond became a popular Christmas card, under the title 'Skating on a Winter's Evening'. It is based on a view of Patching Pond in West Sussex, off the Arundel to Worthing road. Man and nature do not always combine in perfect juxtaposition, but the artist with an eye for composition can always help. The fine country house behind the pond is in fact further back in the trees, but Badmin has moved it forward to the perfect position it occupies here.

Exhibited 1977 R.W.S. Spring Exhibition
Signed: S. R. Badmin
18.5 × 26.5cm (7¼ × 10½in)

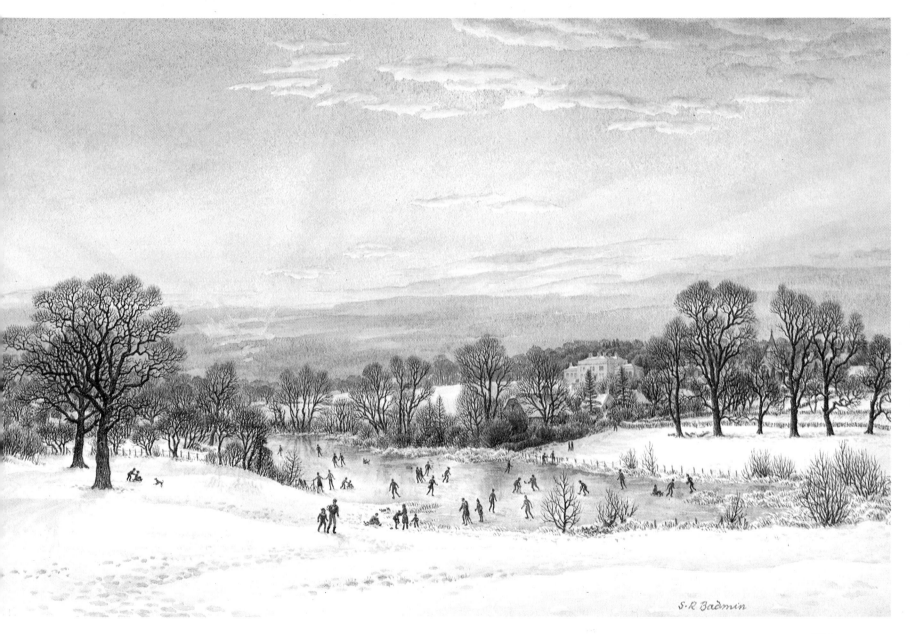

S.R Badmin

Cherry
(3 moles M.hadham
1963 spring
Selham

Spring near Midhurst is one of Badmin's favourite watercolours, just as the view that inspired it is one of his favourite views. It is at Woolbedding, near Midhurst in Sussex. The wild cherry blossoms may still be seen, but the beech clump in the distance has died. So, too, has the splendid wild cherry tree that used to stand near The Three Moles public house in Selham, the other side of Midhurst (left).

Exhibited 1978 R.W.S. Spring Exhibition
Signed: S. R. Badmin and dated 1977; pencil sketch dated 1963

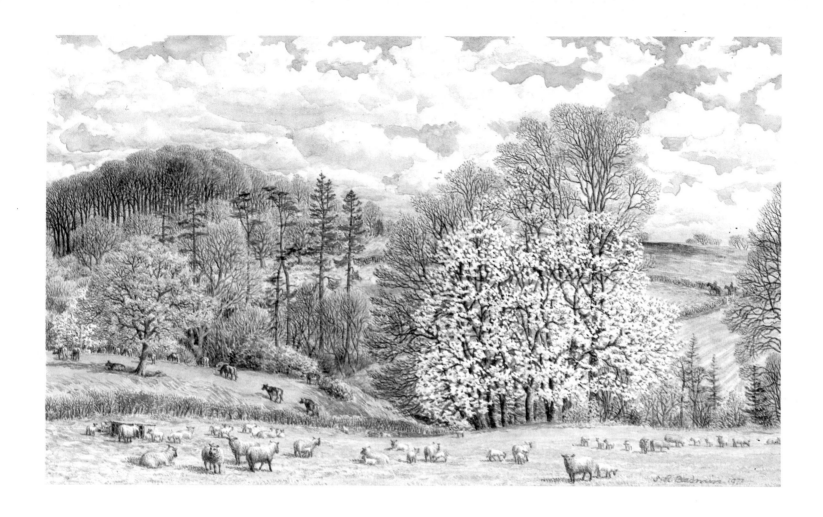

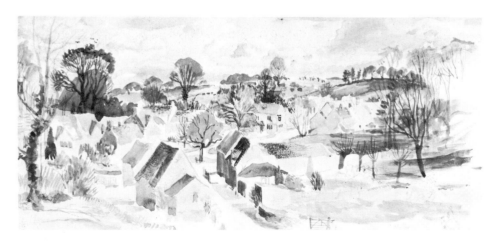

Shilton, near Burford, Oxfordshire. 'The most perfect little village of them all,' is Badmin's verdict on Shilton, one of the prettiest villages in the Cotswolds. He remembers sitting for hours doing this watercolour in a steady north-east wind, but was cheered by a cup of tea brought to him by a woman from a nearby cottage. The end result shows how diligent Badmin is in finding the perfect view. He walked across the entire village seven or eight times before deciding that this was the most picturesque angle.

Exhibited 1977 R.W.S. Spring Exhibition; published 1980 Royle's Artists' Britain Calendar (April) Signed: S. R. Badmin 29 × 42cm (11½ × 16½in)

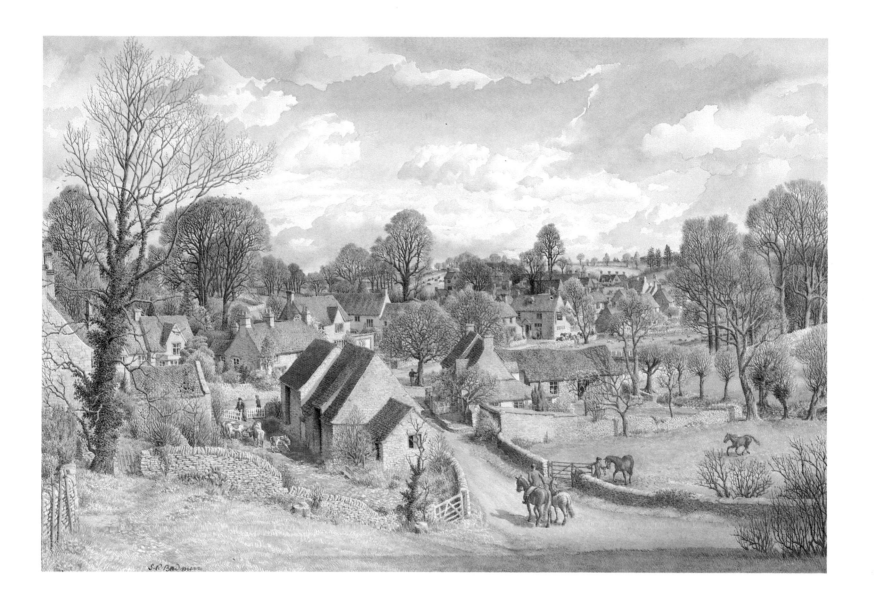

The Avon Gorge is an unusual painting by Badmin's standards, since it was done 'from a photograph, something I don't very often do.' He seemed both surprised and pleased that it turned out so well. The view was commissioned at short notice by *Reader's Digest*, and there was no time for the artist's usual travel, sketching, colour notes and hours of careful, fine finishing. The view, however, has been given an air of bright immediacy, with the fisherman on the bank being a typical Badmin touch.

Exhibited 1978 R.W.S. Spring Exhibition; published as a Reader's Digest *cover*

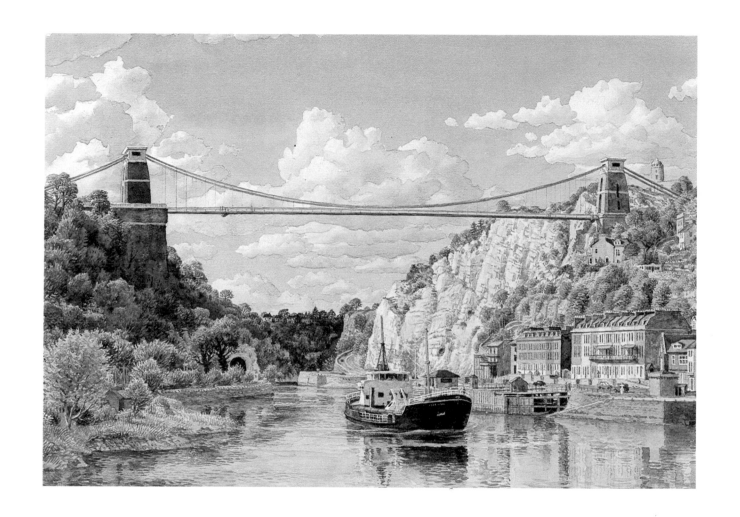

S. Chestnut Hawk
Jany 8. 58

**Wheatham Hill from Steep Marsh, near
Petersfield**, an autumnal view across a busy and
well-kept Hampshire farm, is a virtuoso
performance. From the oak on the left to the
banked and changing colours of oak, ash and
beech, it is Badmin the 'Tree Man' at his very best.

Exhibited 1978 R.W.S. Autumn Exhibition
Signed: S. R. Badmin

Thatching, West Burton, Sussex is one example of the recording of the skills and traditions of the British countryside that is one of Badmin's most important contributions to post-war life. The detailing of the techniques and stages of the art of thatching would brighten any craft text book. In addition, however, the artist gives the scene that vitality that makes the craft an integral part of English village life. The complementary and individual qualities of trees and shrubs are never forgotten, and those such as the magnolia in front of the cottage and the distant cypress would be based on detailed studies.

Exhibited 1979 R.W.S. Spring Exhibition
Signed: S. R. Badmin, inscribed with the title and dated 1978

S.R. Badmin

Thatching, W. Burton &

135

Stopham Bridge from the north-west, autumn.
This ancient and narrow stone bridge with jutting out passing places lies on the busy route from Petworth to Pulborough over the River Arun in West Sussex. Badmin remembers doing much of the work on the spot in the month of October, and recalls in particular standing on top of an old drain cover and dodging the traffic. He sketched the outline in some detail in pencil and added a bit of colour: 'I did a few colour notes, picking out a few stones and made a note of the general tone throughout.' The bridge lies only a few miles from his house and he has returned to the subject often. 'I did the earliest one for my wife in November 1974 when the road flooded and so there were no enormous lorries. 'A new bridge under construction will divert the traffic away from the endangered bridge, so that soon the only threat to painters will be the jostling of their fellows in a favourite spot.

Exhibited 1980 Petworth Festival of Music and Art
Signed and inscribed: S. R. Badmin, Stopham Bridge,
Sussex

137

Amberley Castle from the big barn. Once more, a great length of time was taken to find just the right view before Badmin started to sketch. Permission was first sought of the castle authorities so that the artist-explorer could roam unrestrained. The final half-timbered framing, giving a sensation of moving from dark to light, is so successful that one involuntarily blinks at the thought of emerging into the sunlight. The traditions of the founder members of the Old Watercolour Society are recalled – John Varley would look out on to the reflected light on the surface of the Thames, while Robert Hills would direct back the light from glistening snow. Badmin himself acknowledges the result: 'The good late afternoon light makes it. With the square stones of the castle and the square shadows, it's quite effective.'

Exhibited 1981 R.W.S. Autumn Exhibition
Signed: S. R. Badmin

Kincaudine Castle from
the Big Barn. S.R. Badmin

139

Evening light, Swinbrook. The strange, low light of evening is a difficult effect to achieve in art and is rarely attempted. The result here is entirely successful, but the artist's genius was anticipated nearly fifty years earlier by a critic in *The Studio*: 'From the accumulation of detail an atmosphere is created of a world precise, orderly and, at the same time, dream-like.' It is late spring and new blossom and leaf bring out another virtuoso display of tree-scaping. Badmin's favourite etching, and probably his best, is Swinbrook Bridge, Oxfordshire, done in 1931 (page 54).

Exhibited 1981 R.W.S. Spring Exhibition
Signed: S. R. Badmin and inscribed with the title
12 × 21.5cm (4¾ × 8½in)

Evening Light Swinbrook

S. R. Badmin

141

City Road Lock, Islington shows Badmin's great interest in exploring the town as well as the country. He clearly enjoys the varying characters and moods that can be seen along the towpath of the Grand Union Canal, which travels through the heart of London all the way to the Thames at St Katharine's Dock. As ever, he is responsive to the recreation that people get from their environment. On any day here the lock keeper will be busy allowing pleasure boats and barges through the lock. The cruiser manoeuvring on the capstan is named after Galea, the artist's youngest daughter. And, if you look closely, you will see that the picture is, in fact, signed twice. The green shop-front in the row of Georgian houses beyond the canal displays the name 'S. R. Badmin' – perhaps plying the trade of an Artist's Colourman?

The sketch (left) shows well the artist's method of composition: trial pencil drawing, and blocks of colour falling into the right place.

Exhibited 1983 R.W.S. Autumn Exhibition
Signed: S. R. Badmin
30 × 45.5cm (11¾ × 18in)

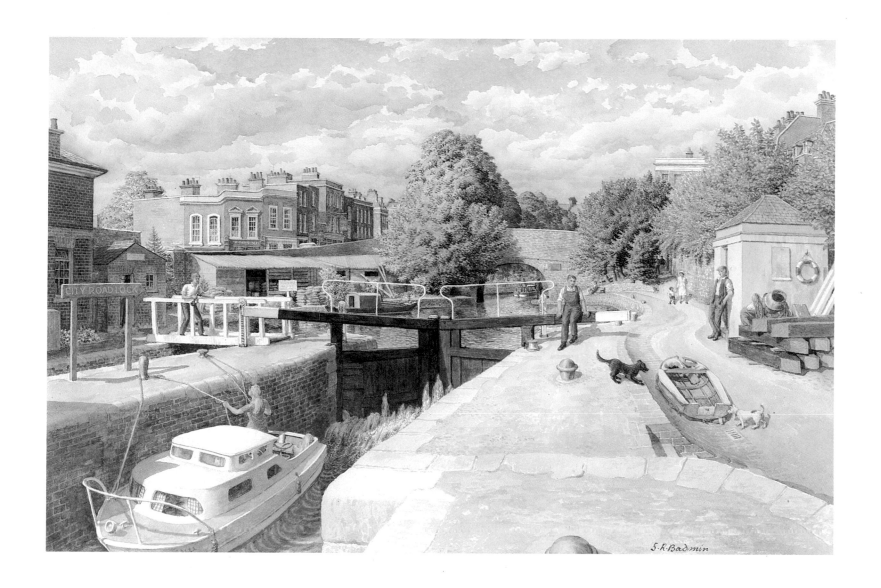

143

Ludlow Castle, autumn. Ludlow Castle in Shropshire is very important to Badmin, and has always been a favourite view of his since he remembers first seeing it while on a tour he took with his father in a motorbike and sidecar. The purpose of the trip was to do sketches, but no inspiration came. 'I didn't like it a bit,' Badmin recalls. 'No sketches. Until Ludlow.' Adrian Bury, in an article on Badmin in the Old Watercolour Society Club volume for 1957, wrote enthusiastically of this view of Ludlow Castle. 'Ludlow Castle still remains the ideal subject, ready made, as it were, by nature and man It has been painted by several great watercolourists from Francis Towne, one of the earliest, to the present day, each adding his quota of reverence to this singularly lovely scene. Technique and sentiment are delicately balanced. The castle stands dominating the Welsh marches, taking its relative place in an immense tract of country – fields, hills, trees, rivers, bridge and other buildings in the foreground. The tonal values, always difficult to realise in so restricted a method as pen, ink and tints, are most convincing in the use of dark accents here and there and the juxtaposition of warm and cold colours.'

Exhibited 1984 R.W.S. Autumn Exhibition; published as a Reader's Digest *cover*
Signed: S. R. Badmin
20.5 × 14.5cm (8 × 5¾in)

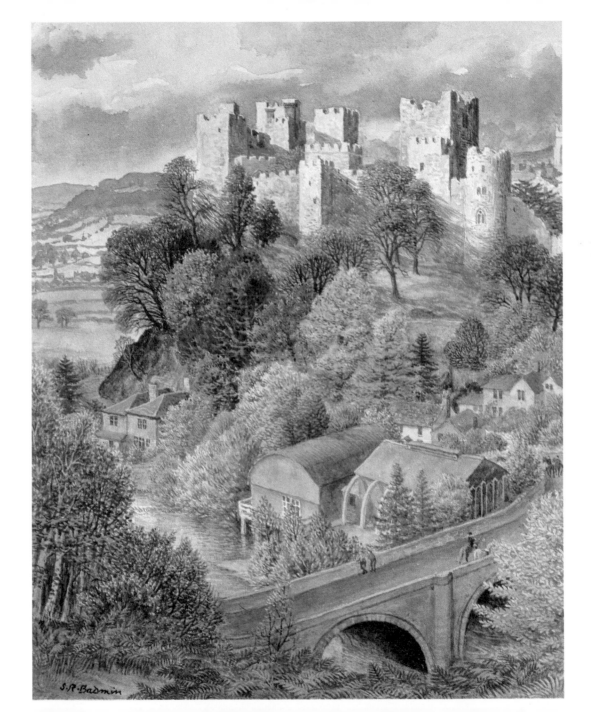

145

Market morning, Farringdon. The market, just setting up, has a busy, bustling feel to it in the early morning light. There is a mingling of lifestyles in this watercolour as all types of people from town and country meet – quite literally if the red car carries on down the wrong side of the road towards the tractor. Boys are dawdling on their way to school, with two of them trying out some tricky footwork with a football – perhaps Badmin was recalling the day he scored a goal against Ipswich Town way back in the 1930s! The artist sketched this scene unnoticed from a first-floor bedroom window in the hotel overlooking the square, without intruding in any way into the jolly scene. From the white candle blossom of the horse chestnut in the churchyard we know that it is spring, and as the rooks are flying off from the distant rookery we also know that it is breakfast-time.

Exhibited 1982 R.W.S. Autumn Exhibition
Signed: S. R. Badmin and inscribed with the title
12.5 × 21.5cm (5 × 8½in)

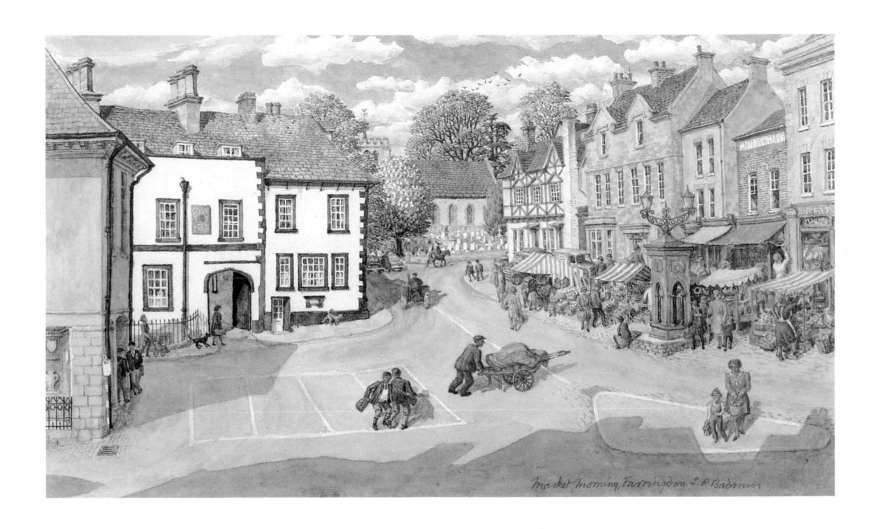

Market Morning, Farringdon. S.R.Badmin

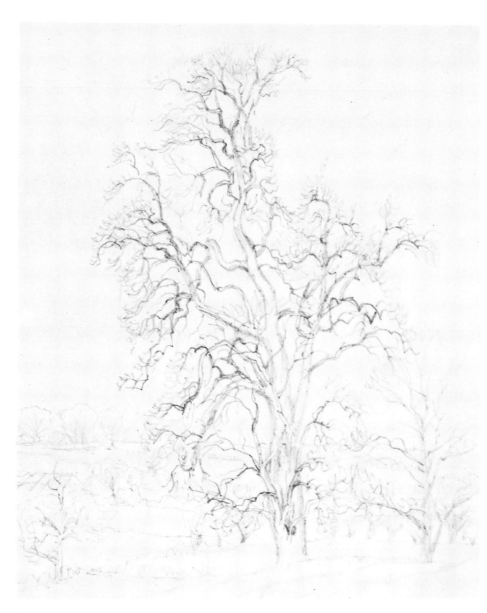

The pear tree in the paddock. If, in spring, you
go up the road from the artist's home to the next
village you will come across this magnificent sight.
To present the time of blossom correctly, a tree
artist needs to know the basic structure of a tree,
just as Stubbs knew the anatomy of a horse. The
skeletal pencil drawing (left) is of a mature pear
tree in winter. The next tree along the hedgerow is
an oak. 'You get oak that colour in the spring – it's
almost autumnal. You notice the orange, caused by
the blossom.' Badmin also pointed out the beech
trees at the back of the field: 'They are hardly
erupted at all, but the buds are on the move. They
were fully out and light green by the time I had
finished the watercolour.'

Exhibited 1983 R.W.S. Spring Exhibition
Signed: S. R. Badmin, inscribed with the title and dated
1983
18 × 24cm (7 × 9½in)

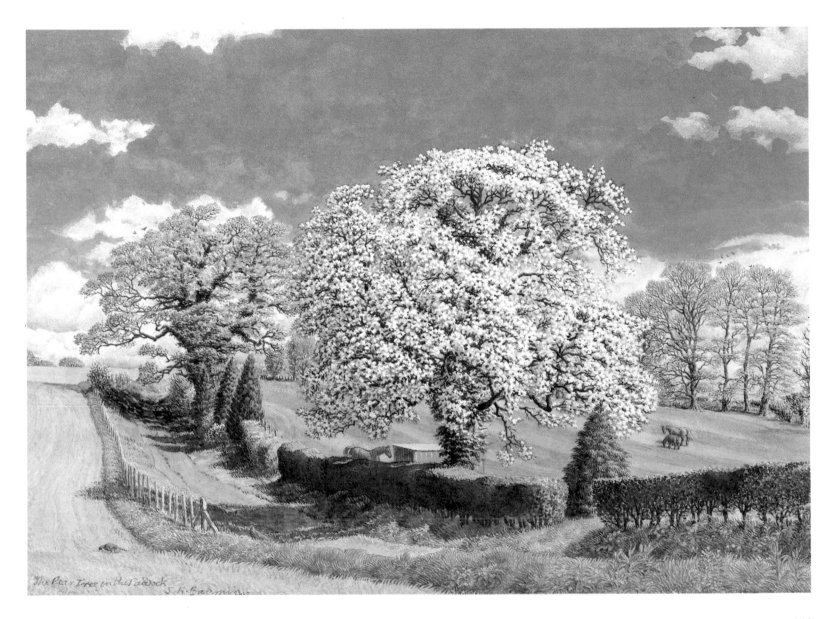

The Pear Tree in the Paddock
S. R. Badmin

149

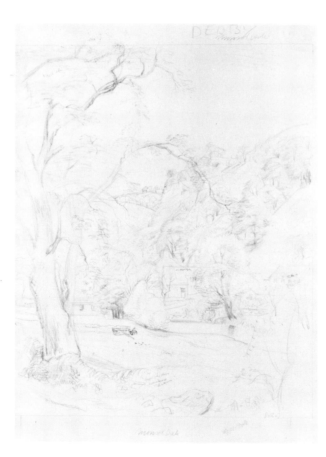

**Monsal Dale in autumn, looking towards
Upperdale** was published as a *Reader's Digest*
cover in November 1983. A wych-elm grows out of
a dry stone wall where rose-hips glisten in the
golden sun. A rabbit hides there, too – ears pricked
and motionless as he listens to the uninhibited
noise of the small child with his father down by the
river. At the end of the half-ploughed field a roller
and harrow have been put aside for the day.

Farm machinery of all sorts – pre- and
post-tractor era, active and rusting, litter the pages
of Badmin's sixty years of sketch books. They form
a visual record of now obsolescent English farm
machinery, such as the disc-and-rake harrow
(above).

Published 1983 Reader's Digest
Signed: S. R. Badmin
24 × 16.5cm (9½ × 6½in)

151

Royal Watercolour Society exhibits

Up to 1936, S = Summer, W = Winter; from 1937 onwards, S = Spring, A = Autumn. The catalogue number precedes each title.

1932 S
- 3 Mill Street, W.
- 48 The Season Commences – Richmond
- 76 Frome, Somerset
- 90 Cornish Mill Farm
- 151 Watercress Beds, near Dorking

1932 W
- 125 Ludlow, April
- 140 The Severn Valley
- 174 Dorset Farm
- 180 Pest House Farm, Sheen
- 186 Clapham Common

1933 S
- 39 Dursely Dough Trough and Cam Peak, Gloucestershire

1933 W
- 4 The Conjunction of the Wye and the Severn
- 11 The Filter Beds, Snodland Paper Mill
- 42 The Creek, Snodland Paper Mill
- 55 Uley, Gloucestershire
- 66 Jackson's Saw Mill, Uley
- 233 Bergen, Norway

1934 S
- 2 Grey Day – Oxfordshire
- 98 Isleworth
- 191 Chelsea Street

1934 W
- 10 Cheyne Row, Chelsea
- 94 Barnard Castle
- 100 Dorking Valley
- 102 Entrance to Fellows' Garden, Wadham College
- 104 Reeth, Yorkshire

1935 S
- 5 Barnard Castle, Yorkshire
- 143 Swinbrook Bridge

1935 W
- 55 Quebec
- 92 Yacht Sheds, Poole

1936 S
- 48 Buoys in the Marine Yard, Quebec
- 72 Avebury Stones, Wiltshire
- 134 Yorkshire Wood

1936 W
- 2 The Rotunda, Stowe
- 36 The Regents Canal, near Paddington
- 79 View of Buckingham
- 86 View of Alkham, Kent
- 148 Last Man In

1937 S
- 72 Chegworth Mill, Top Floor
- 78 Chegworth Mill, First Floor
- 91 Chegworth Mill, Ground Floor

1937 A
- 47 Cottage Garden
- 107 Waites' Boat House, Richmond
- 140 Cottage Greenhouse

1938 S
- 14 Essex Stairs
- 47 Parson's Pleasure

1938 A
- 50 Spring Sunday, Hyde Park
- 142 Autumn, Suffolk
- 154 Bourton-on-the-Water: Bank Holiday
- 160 Eel Pie Island, Twickenham

1939 S
- 4 Naunton, Gloucestershire
- 101 The Temple Boat House, Isleworth
- 124 Cheyne Row

1939 A
- 20 Syon House, Isleworth
- 23 Isleworth Ferry
- 38 Cliveden Reach
- 44 Kingston Bridge
- 54 Essex Farm

1940 S
- 25 Piling Roots on a Frosty Morning
- 29 A Sprinkling of Snow, Suffolk
- 161 The Striped Field

1941 A
- 25 A Mixed Copse
- 33 Buckingham Landscape, Evening
- 84 Buckingham
- 93 Defences on the Kitchen Front
- 102 Felmersham from the Sharnbrook Road

1942 S
- 17 Long Melford Mill
- 22 Moated Farmhouse, Northants
- 116 Wareham Mill
- 118 Cliveden Reach
- 119 Rhayader

1943 A
- 26 Hayfield
- 30 Study of Winter Trees
- 117 Nell Gwynne Farm and Medmenham Church

1944 A
- 113 Pre-War Sunday in Hyde Park
- 123 Stooking Before the Rain
- 128 Quebec from the Ramparts
- 129 Cornfields in the Thames Valley

1945 A
- 65 Cartshed in Savernake Forest
- 130 Henley Regatta, 1945
- 135 Clearing Mist, February Morning
- 152 Kingston Bridge
- 176 Cutting Hay

1946 A
- 132 The Keeper's Cottage
- 136 The Chapel in the Farmyard, Porlock

1947 A
- 21 Butley Priory, near Woodbridge
- 60 Anaesthesia – Old Oak in Staverton Forest
- 191 The Dower House, Lavington Park

1948 A
- 148 Bridges into Scotland
- 154 Croxdale Bridges
- 185 Bridges at Yarm, Yorkshire

Book illustrations

Bax, C., *Highways and Byways in Essex* (Macmillan), 1939

Badmin, S.R., *Village and Town* (Puffin Picture Books, Penguin), 1939

– *Trees in Britain* (Puffin Picture Books, Penguin), 1942

Recording Britain (Oxford University Press in association with The Pilgrim Trust), Volume I, 1946 and Volume II, 1947

Colvin, B., *Trees for Town and Country* (Lund Humphries), 1947

Nicholson, P., *Country Bouquet* (John Murray), 1947

The Nature Lover's Companion (Odhams), 1949

Nature through the Seasons in Colour (Odhams), 1950

The Children's Wonder Book in Colour (Odhams), 1950

The British Countryside in Colour (Odhams), 1951

St Barbe-Baker, R., *Famous Trees* (Dropmore Press), limited edition, 1952

Wightman, R., *The Seasons* (Cassell), 1953

Stapledon, Sir G., *Farm Crops in Britain* (Puffin Picture Books, Penguin), 1955

Grigson, G., *The Shell Guide to Trees and Shrubs* (Phoenix House), 1958

Trees of Britain (The Sunday Times), 1960

Chronology

1906 Born 18 April, Sydenham, South East London

1922 Scholarship to Camberwell Art School

1924 Won Studentship to the Royal College of Art under Randolph Schwabe and William Rothenstein

1925 Transferred from painting to design school under Professor Tristram

1927 Awarded Diploma A.R.C.A.

1928 Continues at Royal College and Camberwell, doing a teacher's training year
Art teacher's Diploma
Introduced to Twenty One Gallery by Robert Sargent Austin

1930 Exhibition, Twenty One Gallery
Married

1931 Slump in etching market
Elected A.R.E.

1932 Elected A.R.W.S.

1933 Exhibition, Fine Art Society

1934 Teaches at Richmond Art School

1935 Six-month tour of the U.S.A. for *Fortune* Magazine
Elected R.E.

1936 Teaches etching at St John's Wood Art School, with P. F. Millard as Co-Principal
Political awareness – joins Artists' International Association
Exhibition, MacDonald's Gallery, Fifth Avenue, New York

1937 Completes illustrations for *Highways and Byways in Essex* for Macmillan
Exhibition, Fine Art Society

1939 *Village and Town* published, his first Puffin Picture Book under the editorship of Noel Carrington
Elected Fellow of R.W.S.

1940 Work for The Pilgrim Trust, *Recording Britain*

1941 Work for Ministry of Information

1942 Work for *Trees for Town and Country* (Puffin Picture Books)
Joins R.A.F. at Henley-on-Thames, working on operational model-making

1945 Large oil painting, 'The Weekend Pass'

1947 *Trees for Town and Country* published

1948 Saxon Artists become his agents
Work for Odhams Press

1949 Travels Britain making studies for *British Countryside in Colour* for Odhams

1950 Remarried

1952 Illustrates *Famous Trees* by St Barbe-Baker

1954 Teaches one day a week at Central School of Art

1955 Exhibition, Leicester Galleries

1958 *Shell Guide to Trees and Shrubs* published

1959 Moves to Bignor, West Sussex

1967 Exhibition, Worthing Art Gallery, West Sussex

1984 Exhibition, R.W.S. Bankside Gallery

1985 Major Retrospective Exhibition, Chris Beetles Gallery

Index